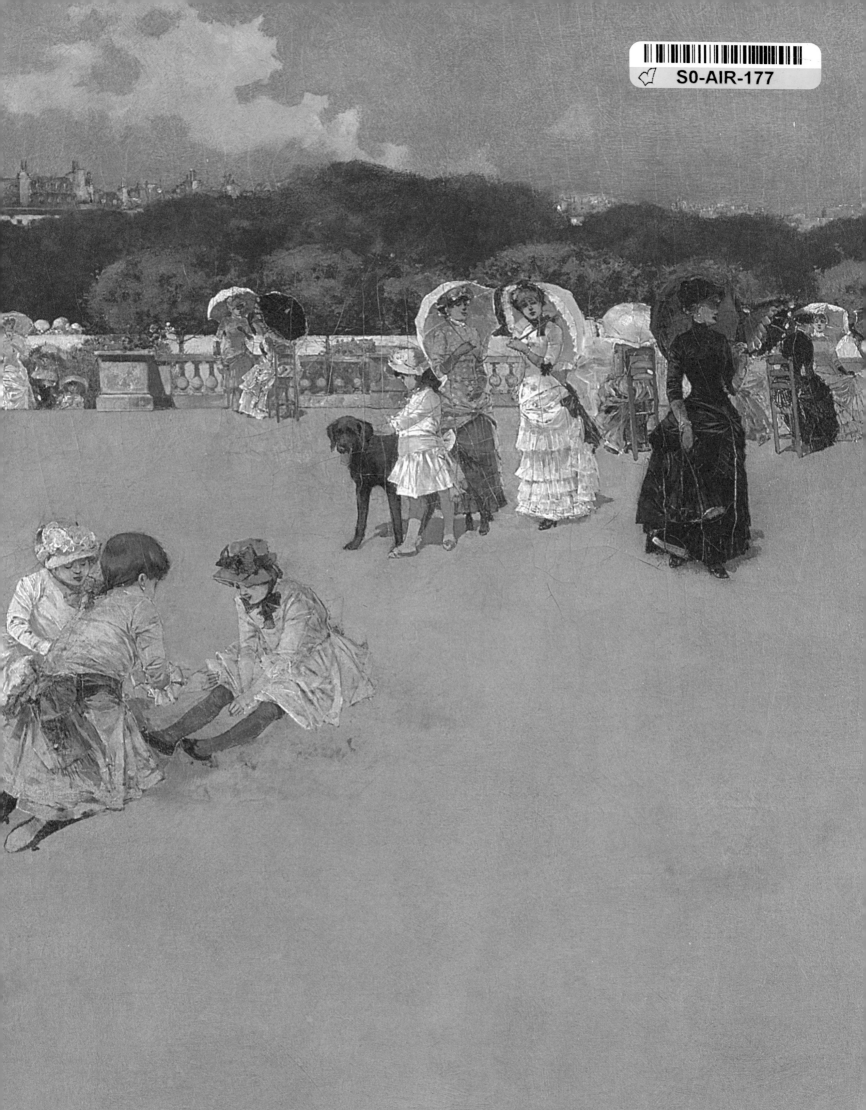

110 Years of American Art: 1830–1940

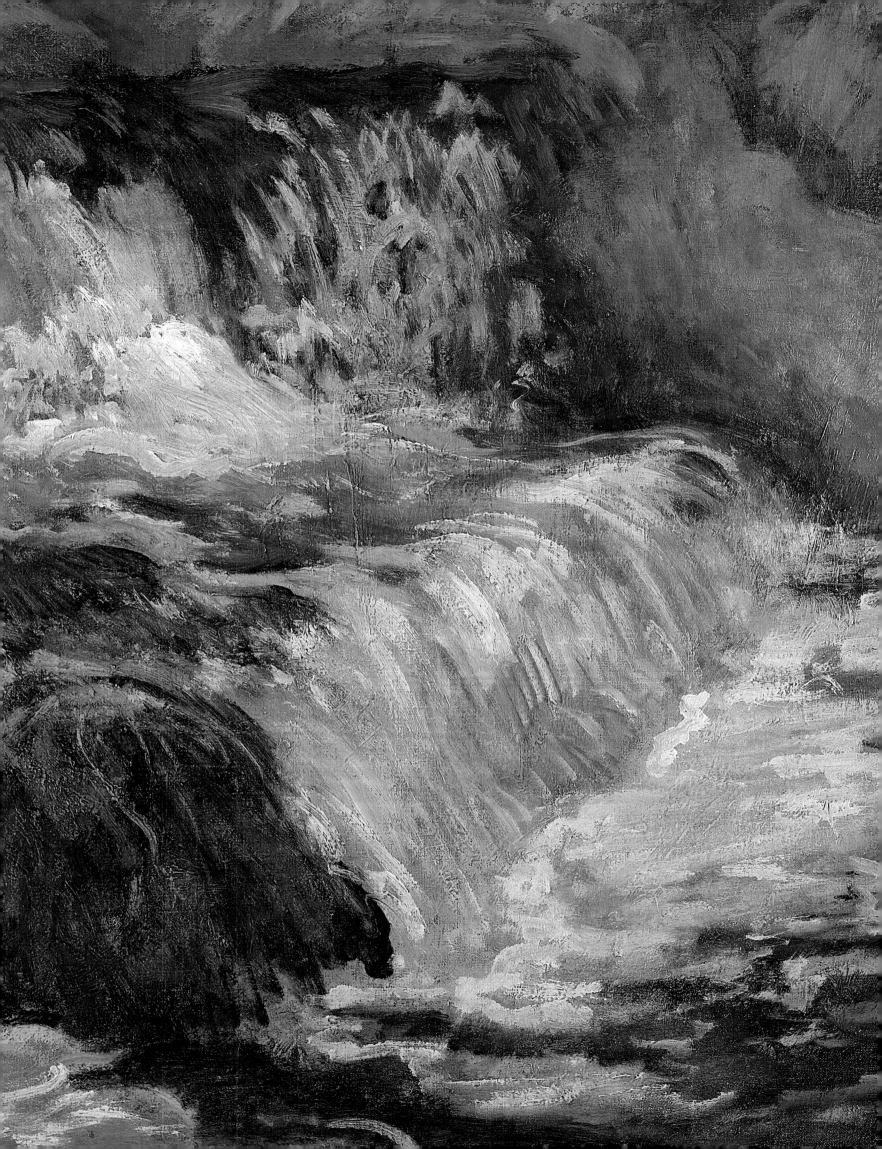

110 Years of American Art: 1830–1940

October 15–December 31, 2001

Spanierman Gallery, LLC

www.spanierman.com

45 East 58th Street New York, NY 10022 Tel (212) 832-0208 Fax (212) 832-8114 info@spanierman.com

COVER:
Arthur Wesley Dow (1857–1922)
Frost Flowers, Ipswich, Massachusetts (detail of cat. 26)

FRONT ENDLEAF:
Fernand H. Lungren (1859–1932)
The Gardens of Luxembourg (detail of cat. 25)

FRONTISPIECE:
John Henry Twachtman (1853–1902)
The Cascade, Greenwich, Connecticut (detail of cat. 64)

BACK ENDLEAF:
Alfred Thompson Bricher (1837–1908)
Saco River, New Hampshire (cat. 13)

Published in the United States of America in 2001 by
Spanierman Gallery, LLC, 45 East 58th Street, New York, NY 10022

Library of Congress Control Number: 2001094440

ISBN 0-945936-44-3

Design: Marcus Ratliff
Composition: Amy Pyle
Photography: Roz Akin
Lithography: Meridian Printing

Acknowledgments

IT IS MY great pleasure to present the eighty-five paintings and sculptures included in this exhibition and catalogue, *110 Years of American Art: 1830–1940*. The works exemplify what Spanierman Gallery, LLC has been doing for over fifty years: presenting museum-quality American paintings, sculpture, and works on paper in many styles and price ranges. As fine works of art from the nineteenth and early twentieth centuries have become increasingly rare, I feel uniquely blessed to have the opportunity to steward them through the gallery on their way to private collections and museums.

This satisfying project would not have been possible without the help of the entire Spanierman Gallery staff to organize, register, archive, photograph, frame and care for these works in very many ways. The tireless and excellent efforts by Marcus Ratliff and Amy Pyle on this and all of our catalogues are invaluable. Special thanks are due to Ira and Gavin Spanierman. Thank you all for your help.

Deborah Spanierman

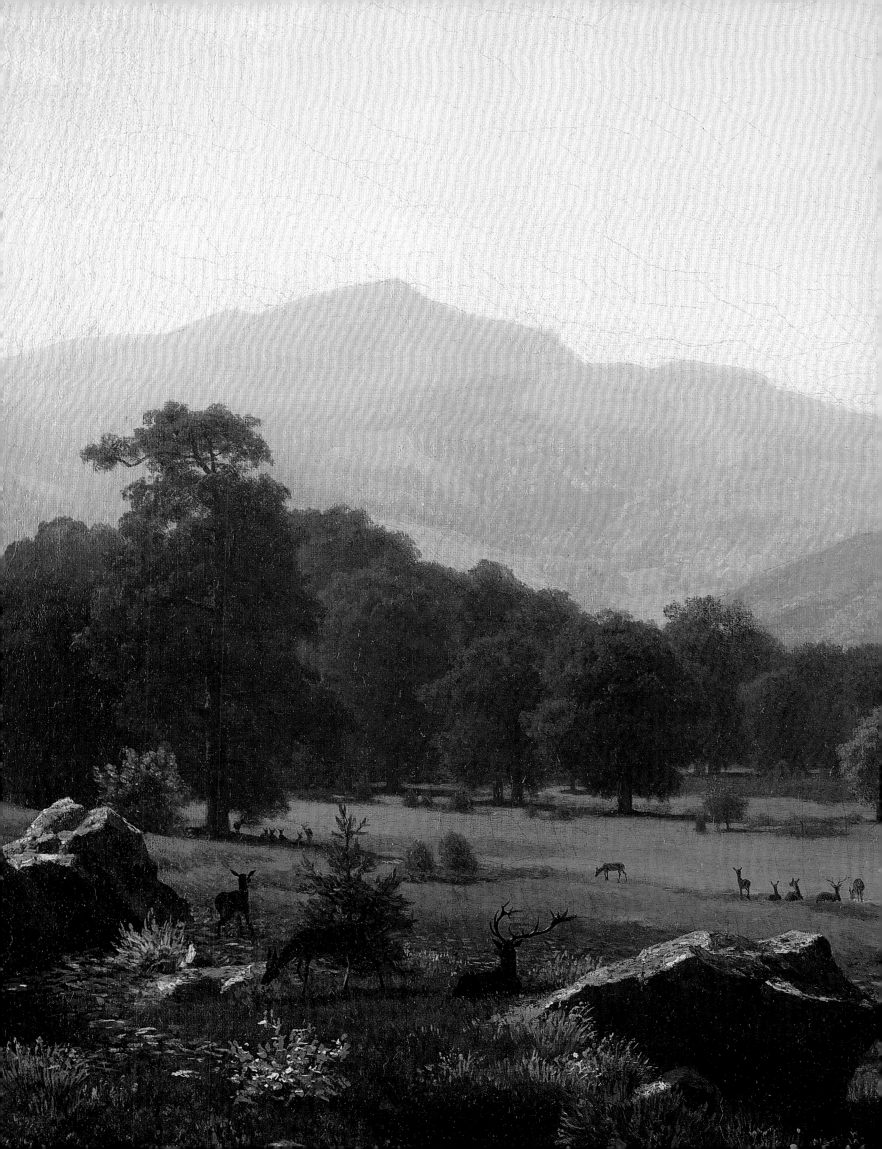

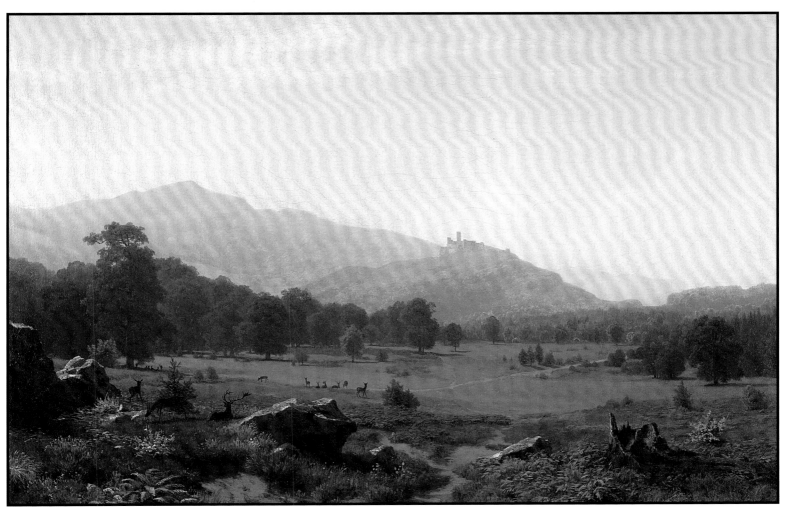

1. **Albert Bierstadt** (1830–1902)

Autumn in the Conway Meadows Looking towards Mount Washington, New Hampshire, 1858,
oil on canvas, 19 × 28 inches, signed and dated lower right: *ABierstadt 1858*

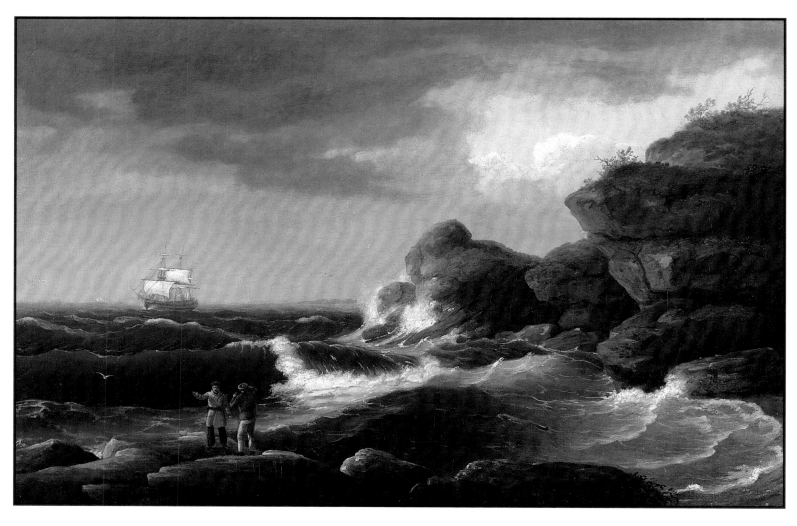

2. **Thomas Birch** (1779–1851)

Coastal Scene, 1830, oil on canvas, 20 × 30 inches

signed and dated lower left: *Tho' Birch/1830*

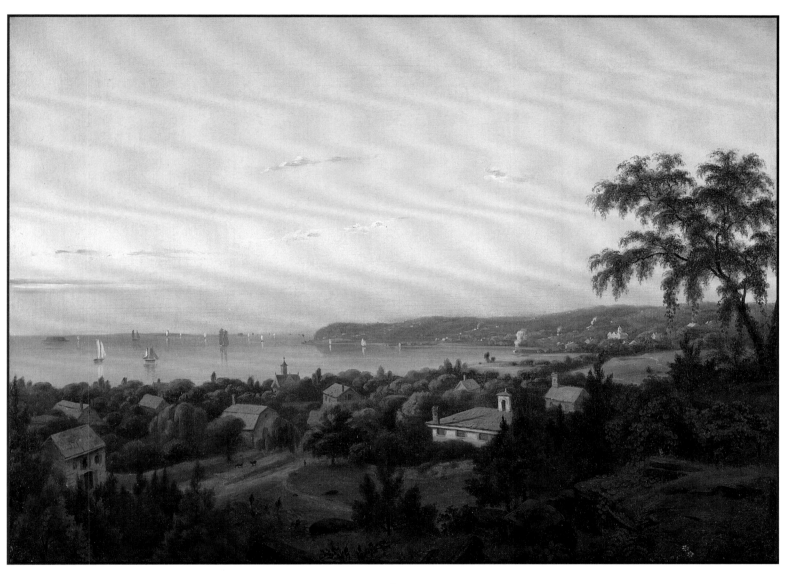

3. **Mauritz F. H. deHaas** (1832–1895)
View of Irvington Looking toward Tarrytown, New York, 1856, oil on canvas, 18 × 24 inches,
signed and dated lower left: *M. F. de Haas 56*

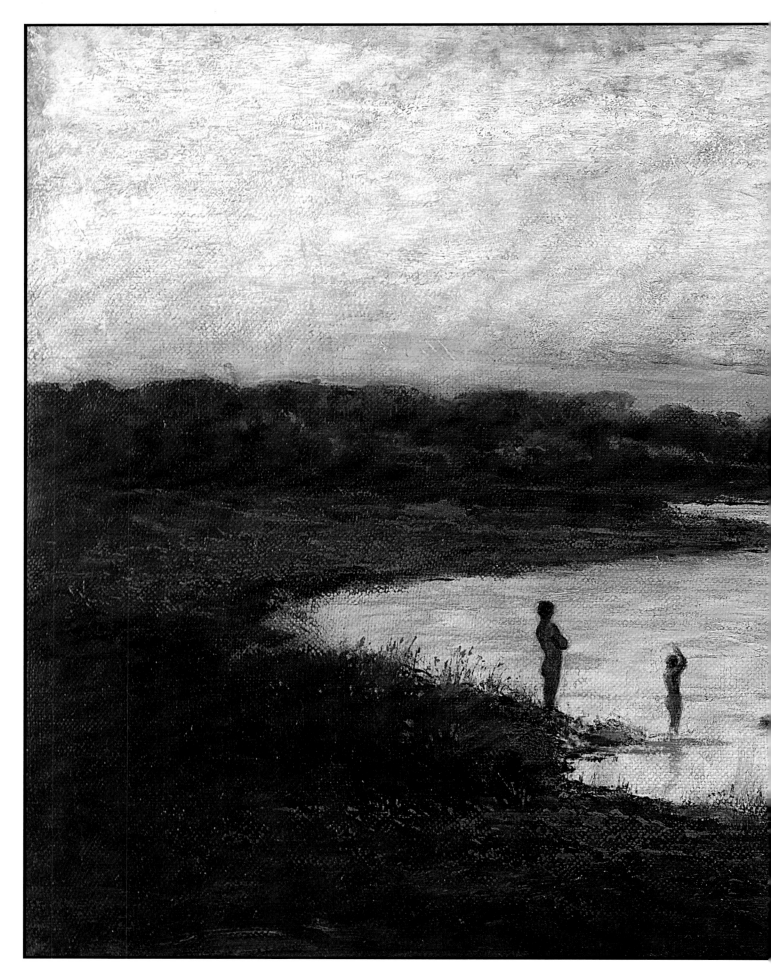

4. **William Morris Hunt** (1824–1879)

Summer Twilight, ca. 1877, oil on canvas, 25⅛ × 39⅛ inches,
signed lower left with monogrammed initials: *WMH*

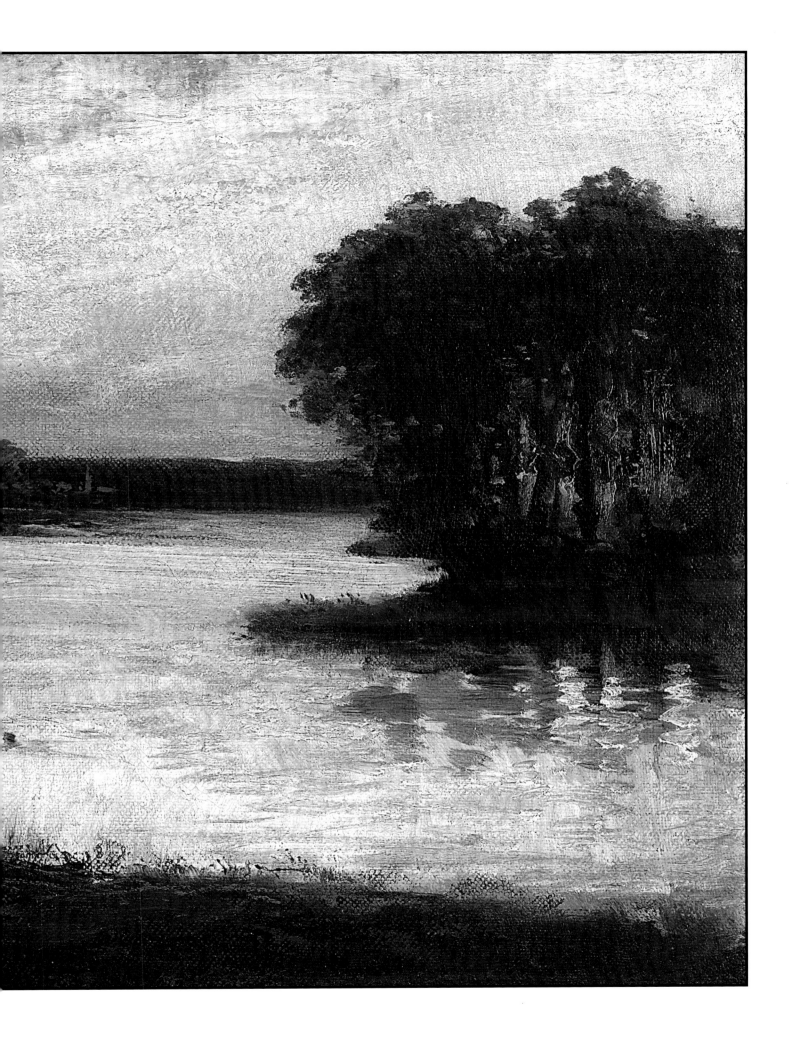

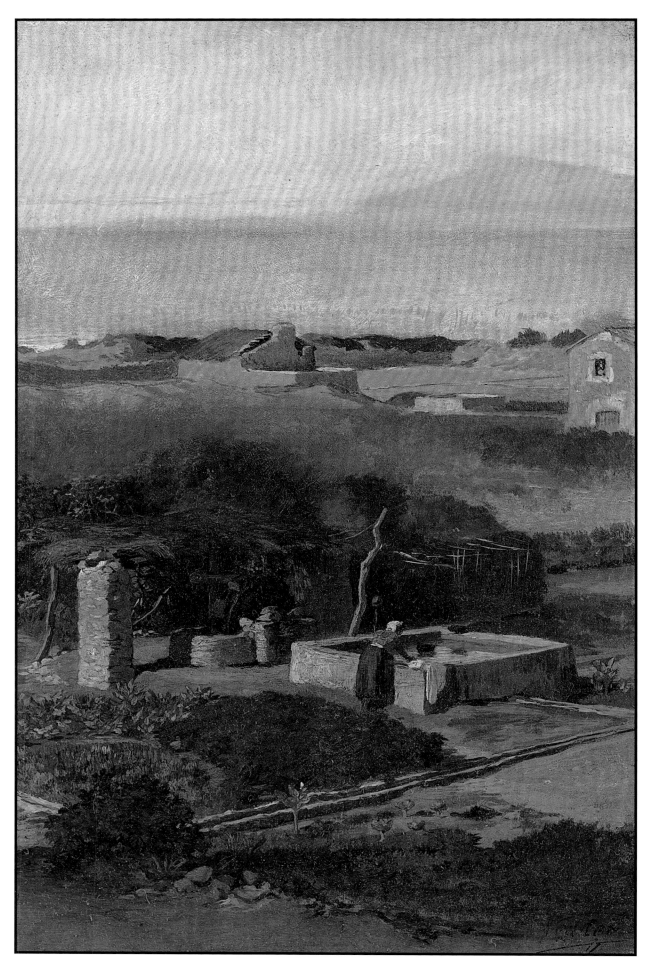

5. **Elihu Vedder** (1836–1923)

Bordighera, Italy, ca. 1880, oil on panel, 12½ × 8 inches,
signed lower right: *Vedder*

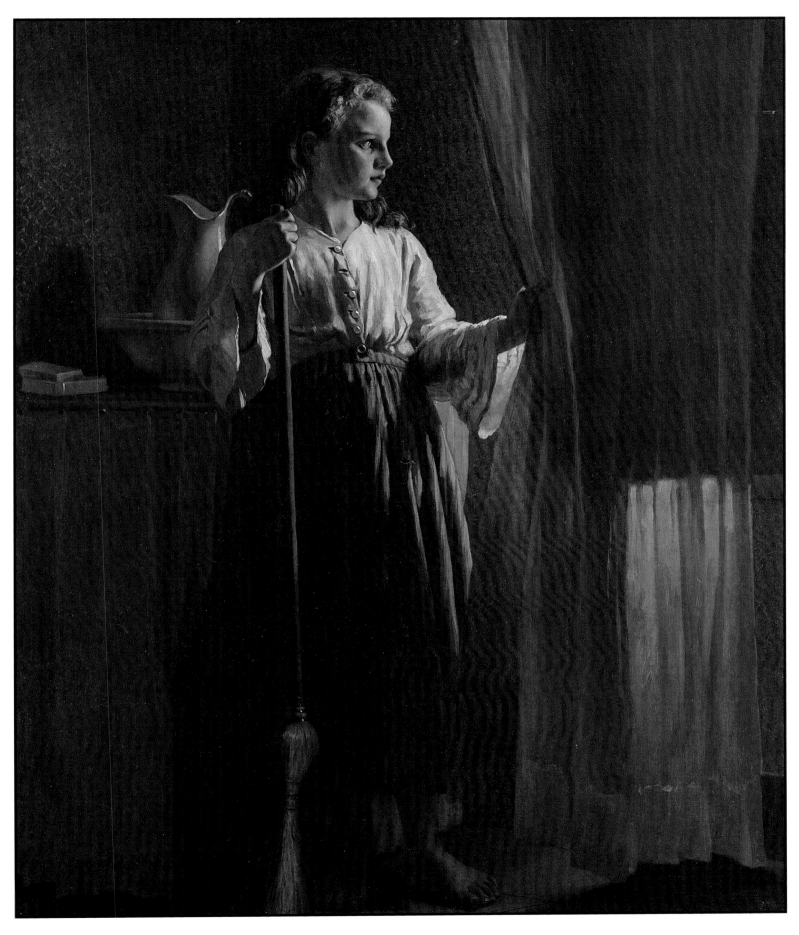

6. **John George Brown** (1831–1913)
The Little Servant, ca. 1886–91, oil on canvas, 30 × 25¼ inches,
signed lower left: *JG Brown N.A.*

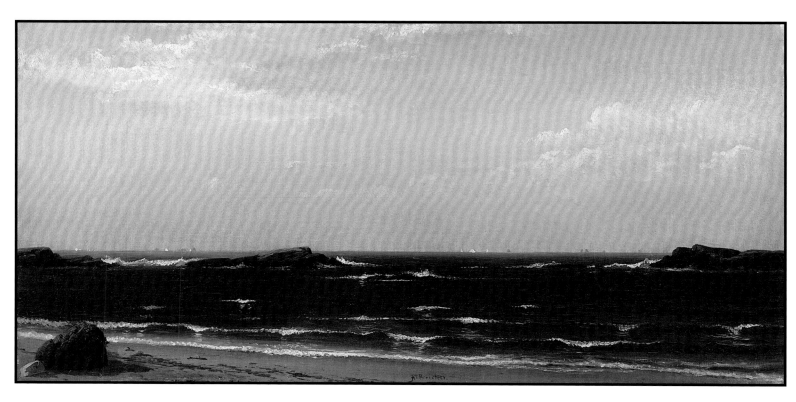

7. **Alfred Thompson Bricher** (1837–1908)
White Caps, after 1885, oil on canvas, 15 × 30 inches,
signed lower center with monogrammed signature: *ATBricher*

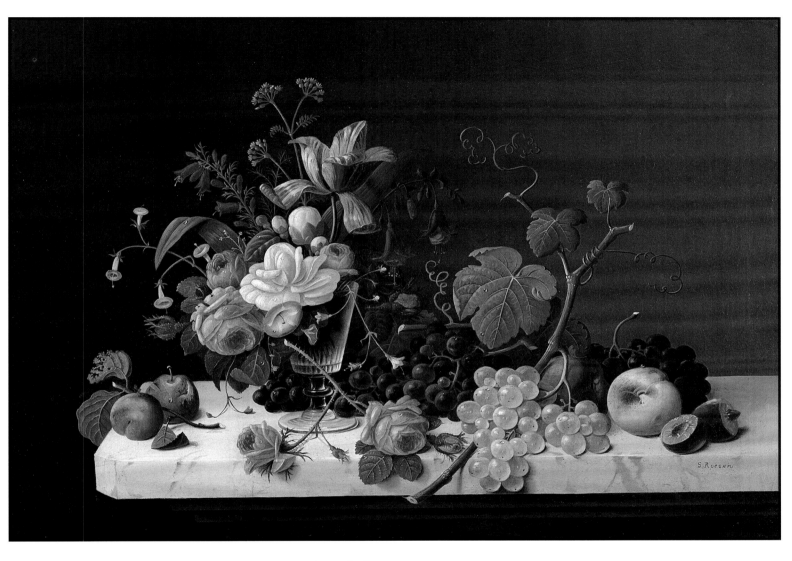

8. **Severin Roesen** (ca. 1815–1872)
Fruit and Flowers on a Marble Table Ledge, after 1860, oil on canvas, 25¼ × 35¼ inches,
signed lower right: *S. Roesen*

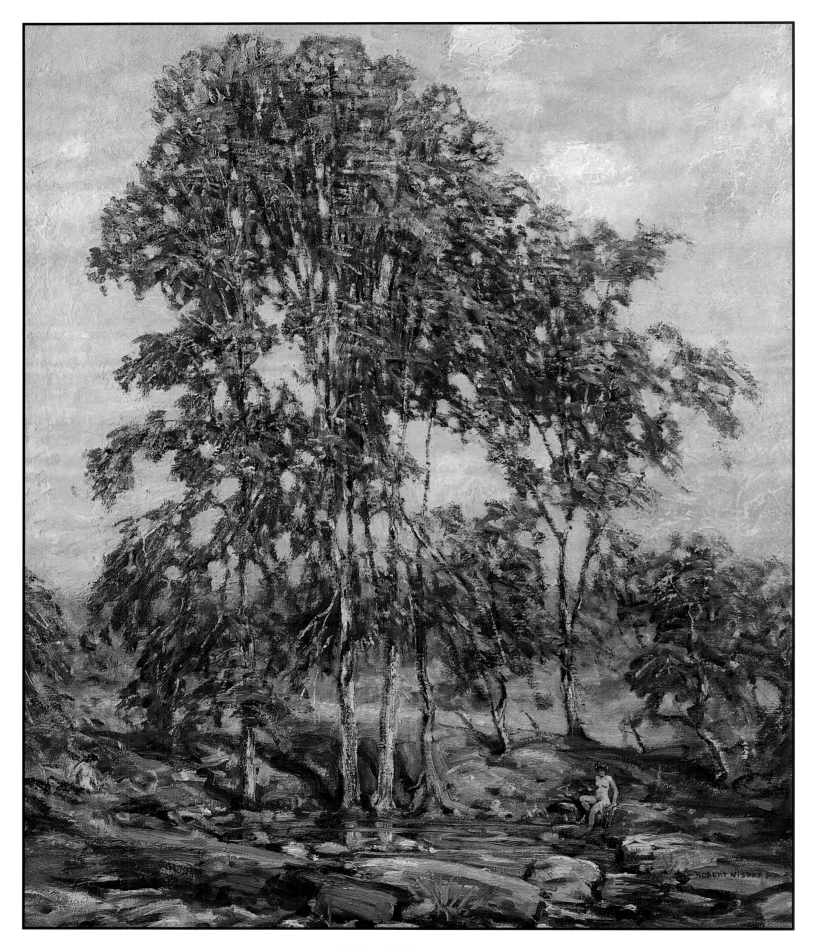

9. **Robert Nisbet** (1879–1961)
Bathing Outdoors, New England, ca. 1910s, oil on canvas, 24 × 30 inches,
signed lower right: *Robert Nisbet*

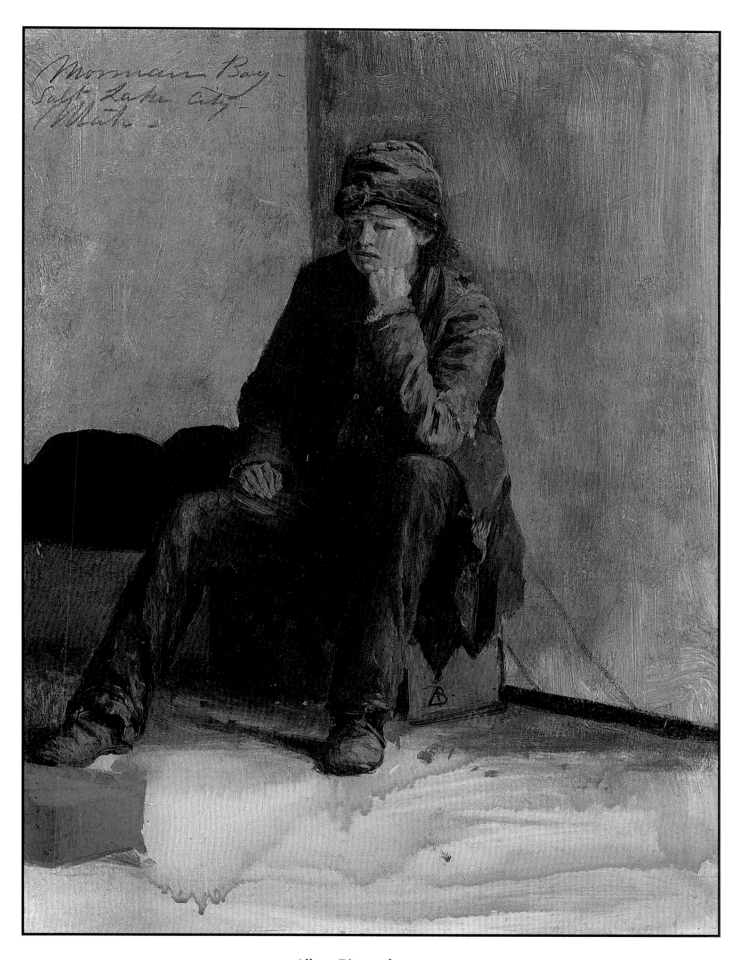

10. Albert Bierstadt (1830–1902)
Mormon Boy, Salt Lake City, Utah, 1863, oil on panel, 13½ × 10½ inches,
signed lower right with monogrammed initials: *AB*; titled upper left: *Mormon Boy-Salt Lake City-Utah*

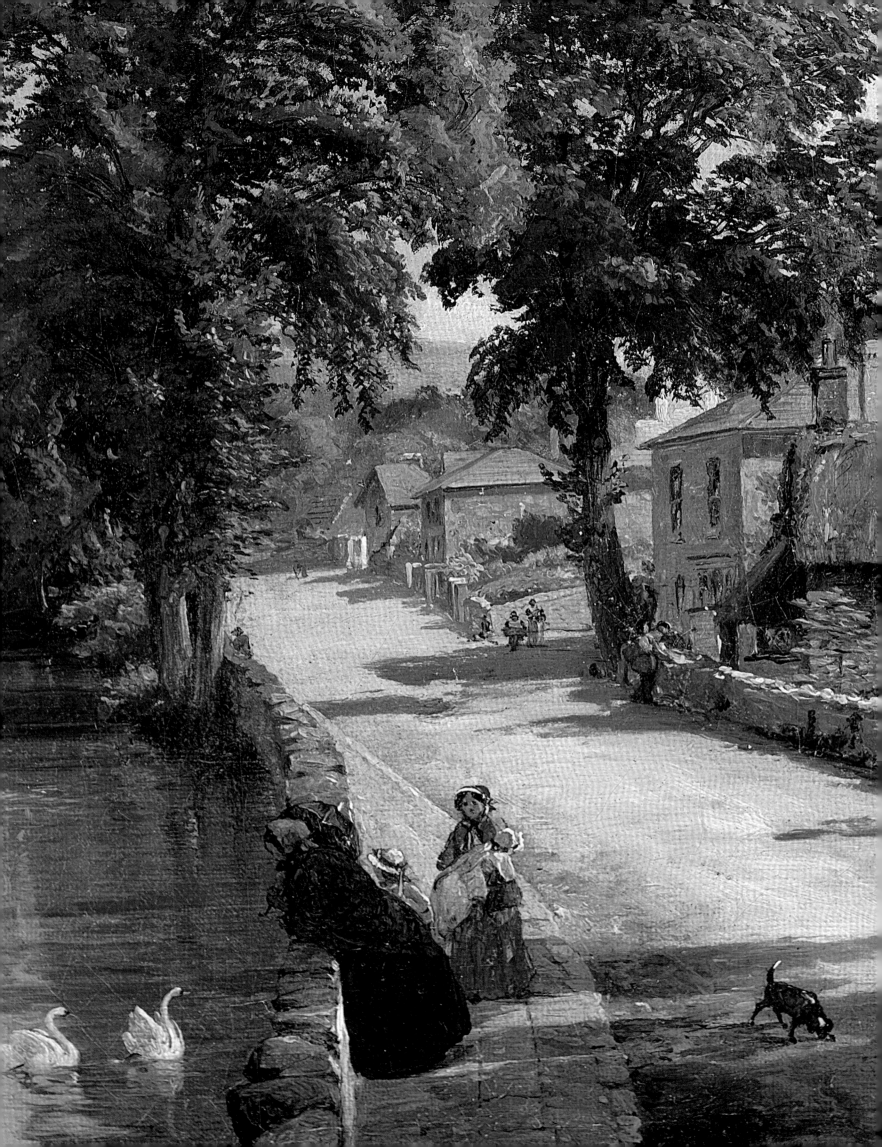

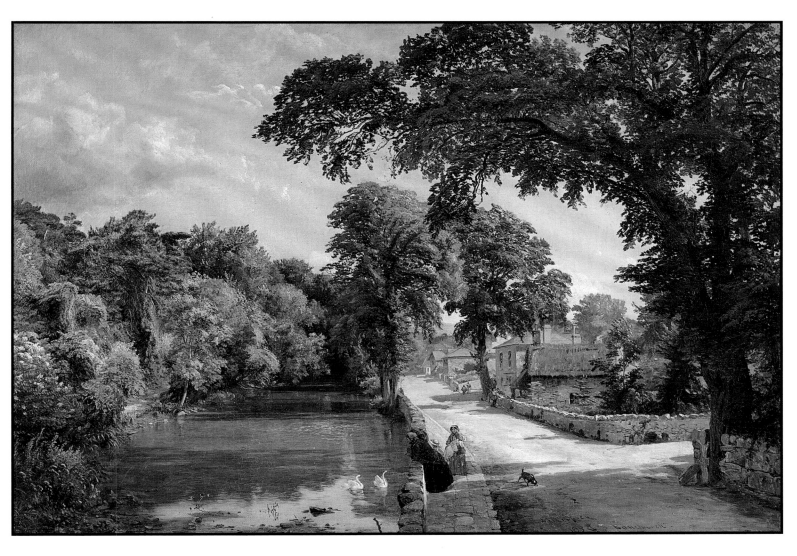

11. Jasper Francis Cropsey (1823–1900)
Bonchurch, Isle of Wight, 1859, oil on canvas, 14 × 20 inches,
signed, dated, and inscribed lower right: *J. F. Cropsey/1859 Bonchurch*

12. **Edward Gay** (1837–1928)
The Meadow, Sweet with Hay, probably Long Island, New York, ca. 1880s, oil on canvas, 20 × 30 inches,
signed lower left: *Edward Gay*

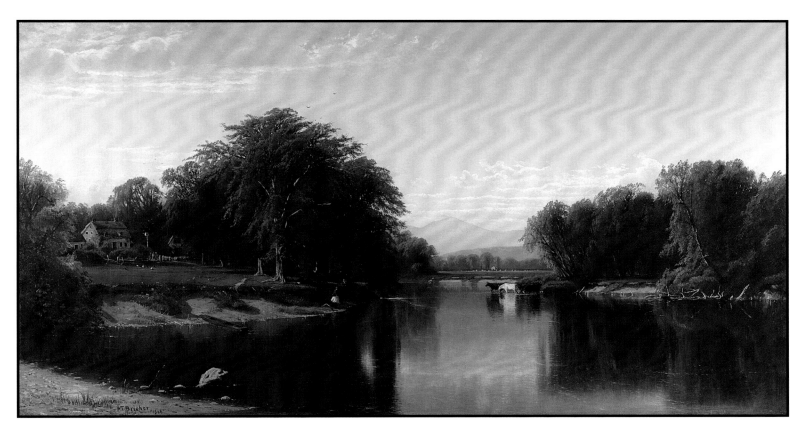

13. **Alfred Thompson Bricher** (1837–1908)

Saco River, New Hampshire, 1868, oil on canvas, 26½ × 49½ inches,
signed and dated lower left: *A.T. Bricher/1868*

(See back endleaf for an enlarged detail)

14. **Charles Harry Eaton** (1850–1901)
Boating on a Waterway, ca. 1880s, oil on canvas, 27 × 43 inches,
signed lower left: *C. Harry Eaton*

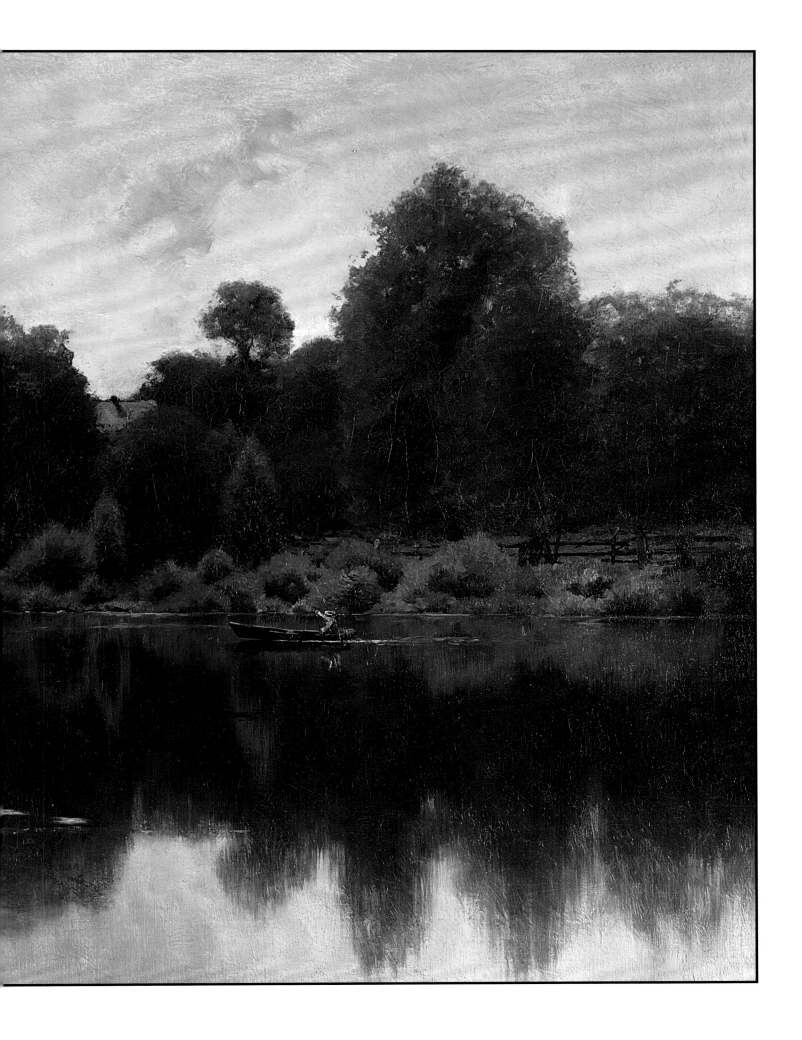

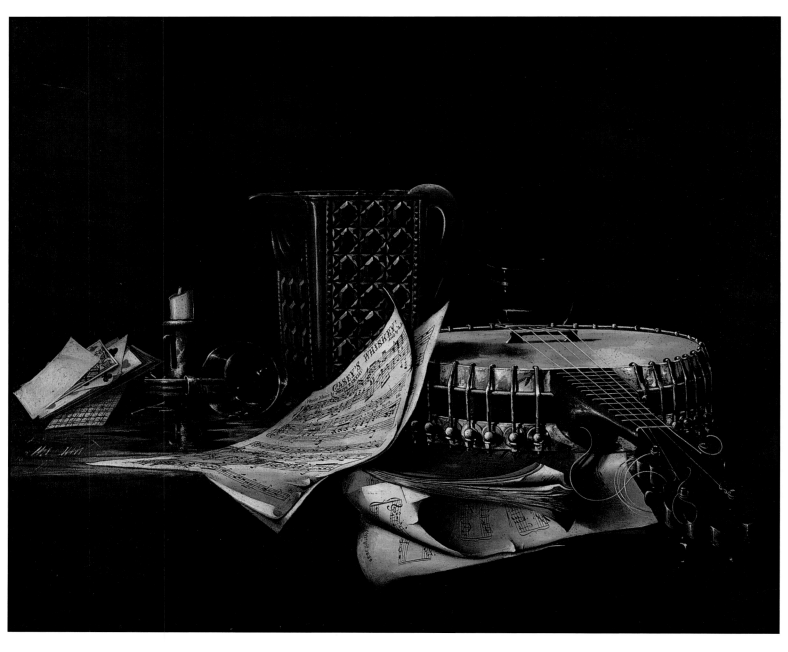

15. Attrib. Thomas H. Hope (1832–1926)
A Still Life: Banjo, Book, and Cards, ca. 1890, oil on canvas, 25 × 30 inches

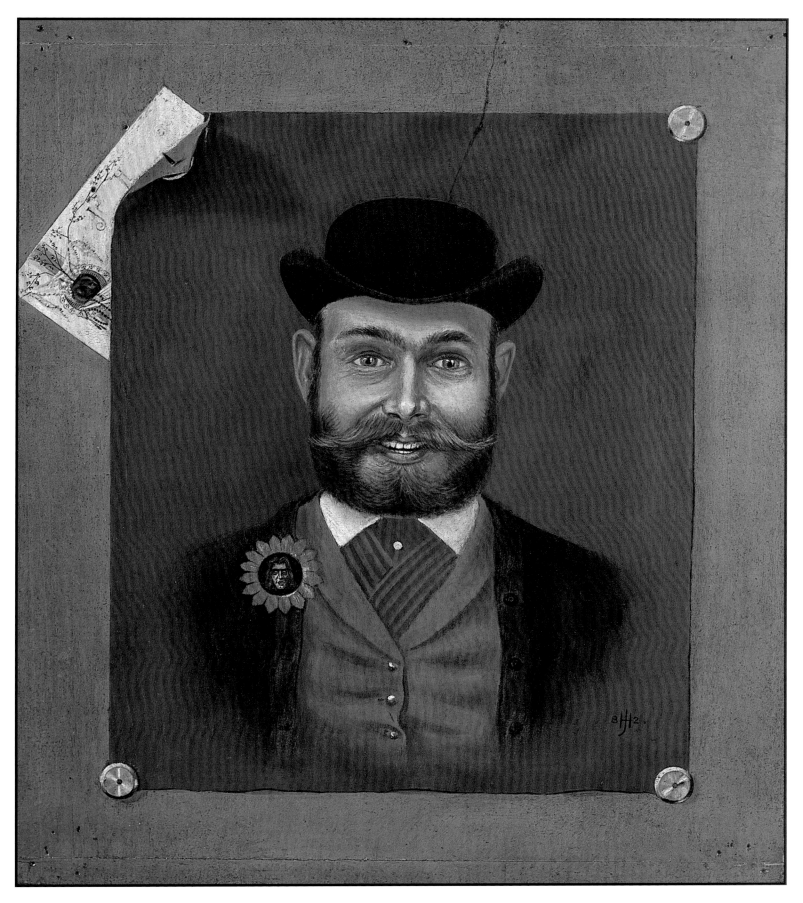

16. **John Haberle** (1856–1933)
That's Me (Self Portrait), 1882, oil on panel, 11 × 9½ inches,
signed with monogrammed initials and dated lower right: *8JH2*

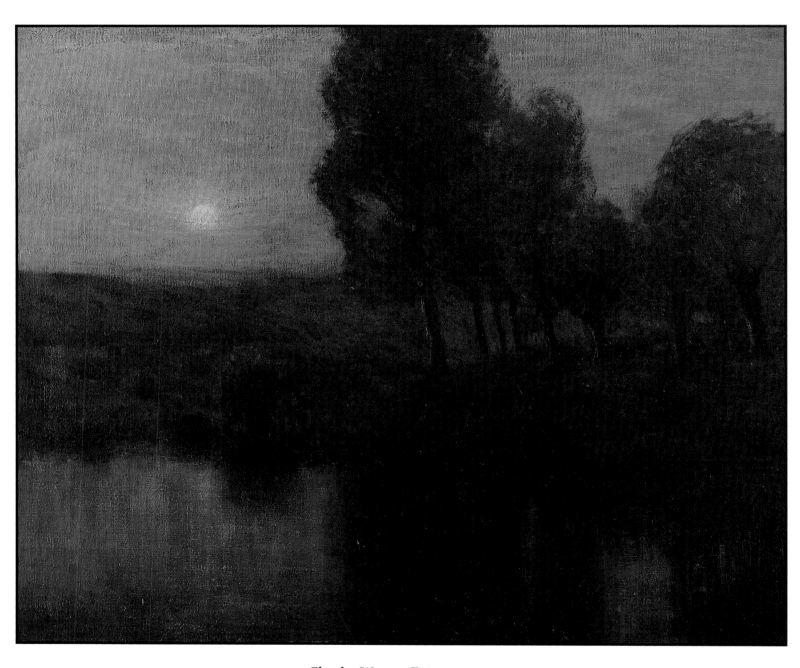

17. **Charles Warren Eaton** (1857–1937)

The Golden Hour (The Morris Canal, Bloomfield, New Jersey), ca. 1900–10, oil on canvas, 30 × 36 inches,
signed lower right: *Chas Warren Eaton*

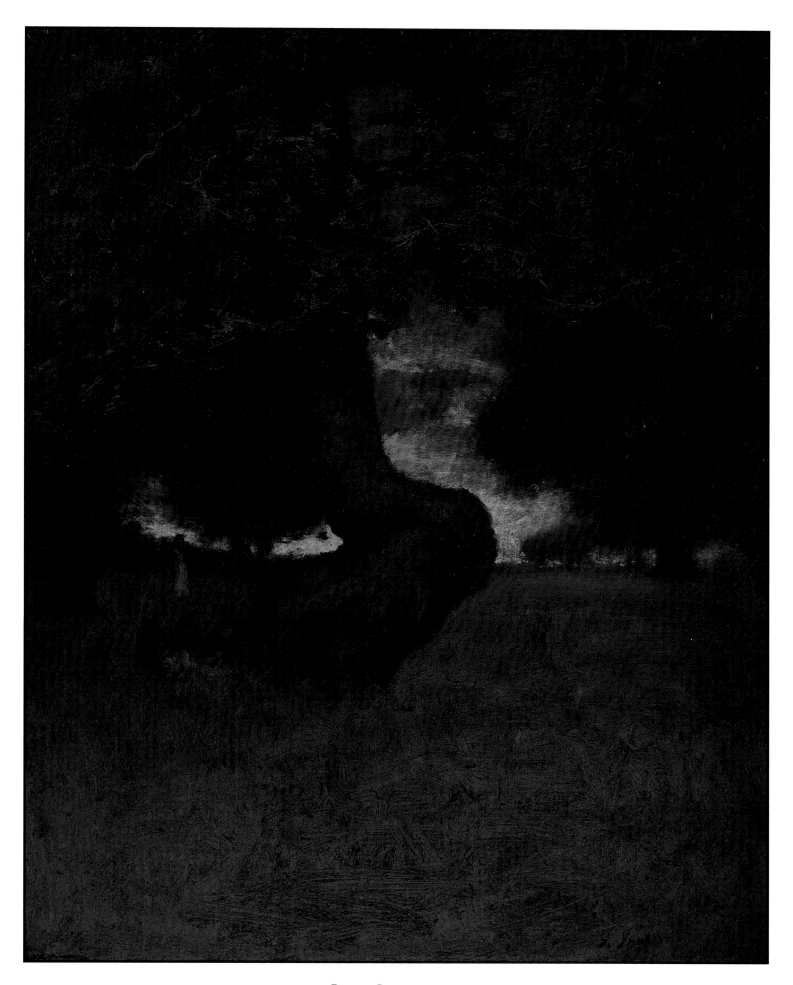

18. **George Inness** (1825–1894)
Sundown, ca. 1889, oil on board mounted on panel, 23½ × 18½ inches,
signed lower right: *G. Inness*

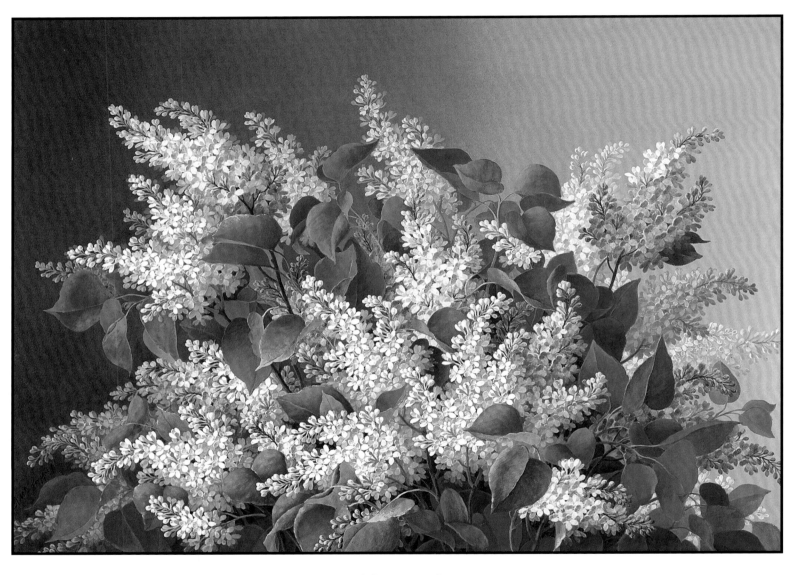

19. **Raoul de Longpré** (b. 1843)
Spray of Lilacs, ca. 1890s, 20¾ × 28½ inches, watercolor and gouache on paper,
signed lower left: *R M de Longpre fils*

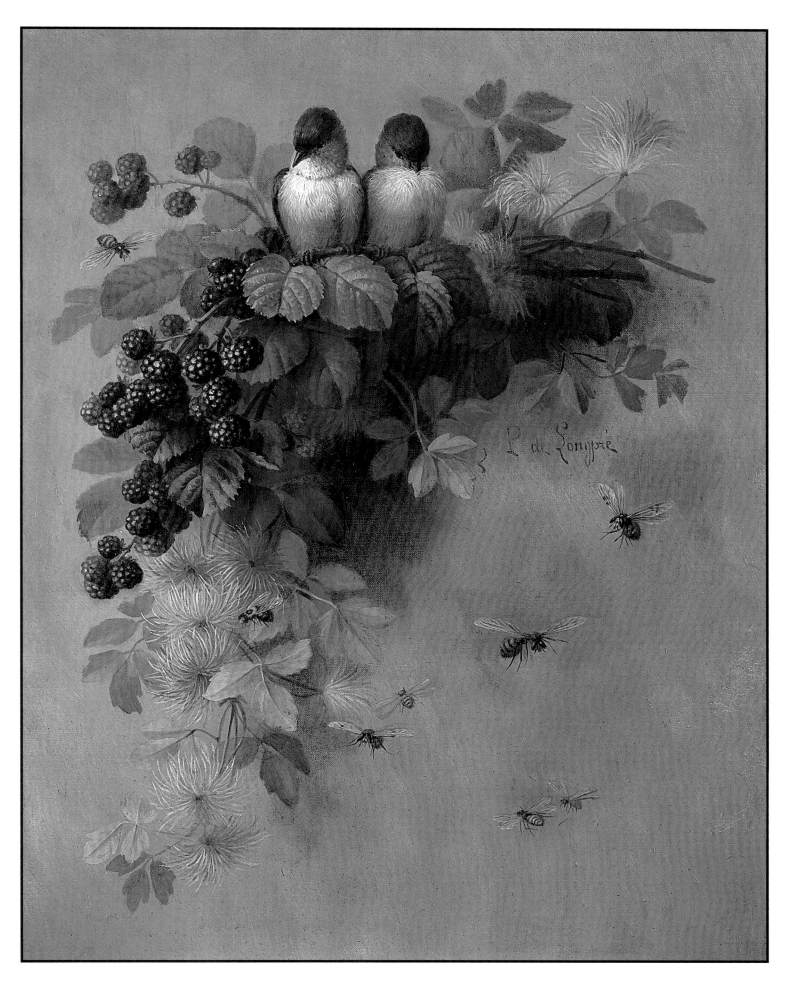

20. **Paul de Longpré** (1855–1911)

Birds, Bees, and Berries, ca. 1900, oil on board, 14 × 10¾ inches,
signed middle right: *P. de Longpré*

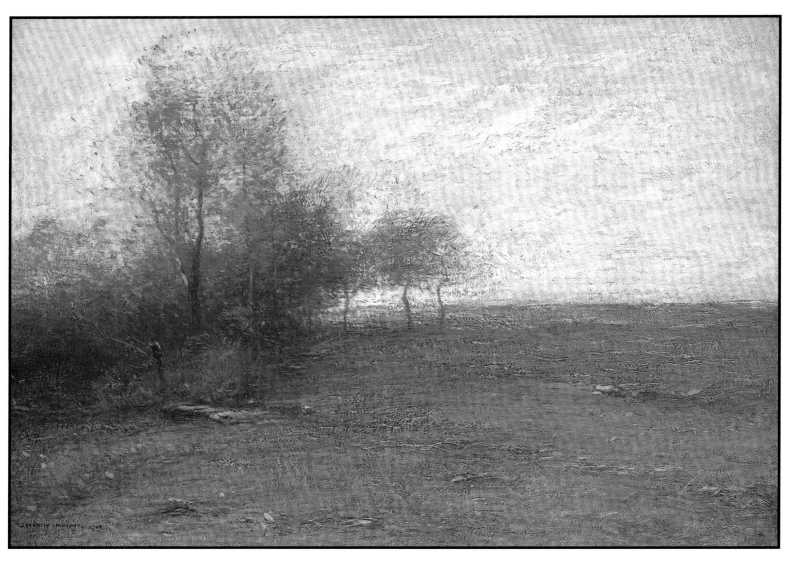

21. **John Francis Murphy** (1853–1921)

Paysage au Feu de Broussailles, 1903, oil on canvas, 16 × 22 inches,

signed and dated lower left: *J. Francis Murphy 1903*;

also stamped with the artist's monogrammed initials *JFM* on the original panel backing

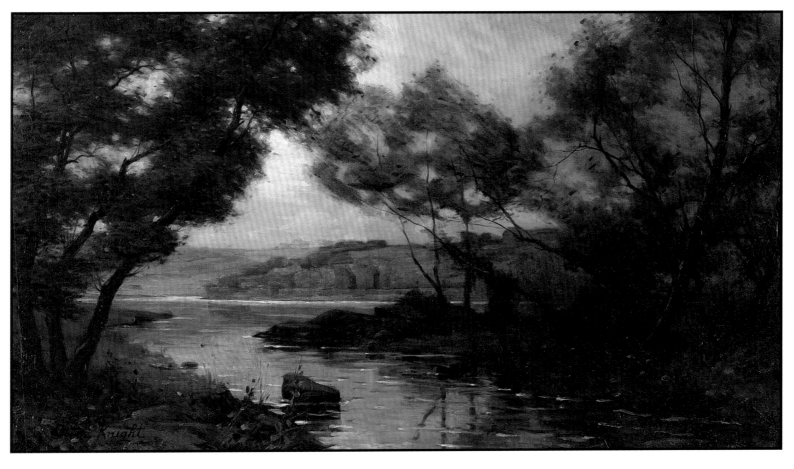

22. **Louis Aston Knight** (1873–1948)

River View, ca. 1910s–20s, oil on canvas, 27 × 45¾ inches,
signed and inscribed lower left: *Aston Knight Paris*

23. Paul Cornoyer (1864–1923)

Old House, Moonlight, Gloucester, Massachusetts, ca. 1910s, oil and charcoal on paper mounted on canvas, 22 × 27 inches,
signed lower left: *Paul Cornoyer;* titled verso: *Old House Moonlight (Gloucester)*

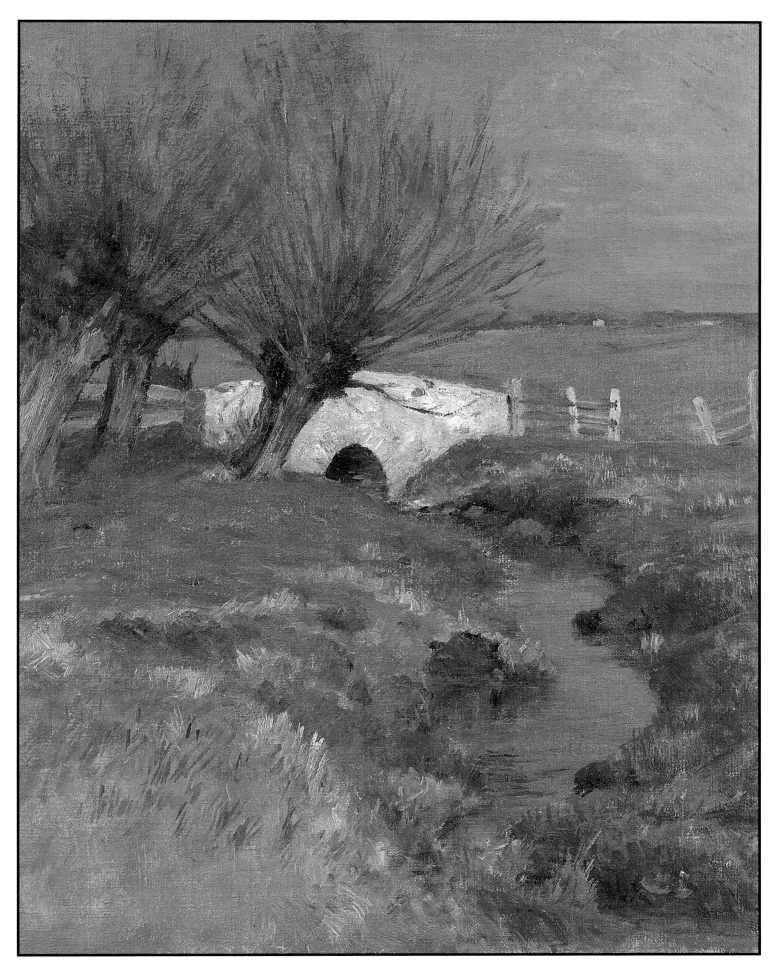

24. **Walter Clark** (1848–1917)
Weeping Willow Bridge, ca. 1910s, oil on canvas, 18 × 14 inches,
stamped with the artist's estate stamp on verso

25. **Fernand H. Lungren** (1859–1932)

The Gardens of Luxembourg, ca. 1882, oil on canvas, 30½ × 58 inches,

signed lower right: *Lungren*; also signed lower right with the artist's cipher

(See front endleaf for an enlarged detail)

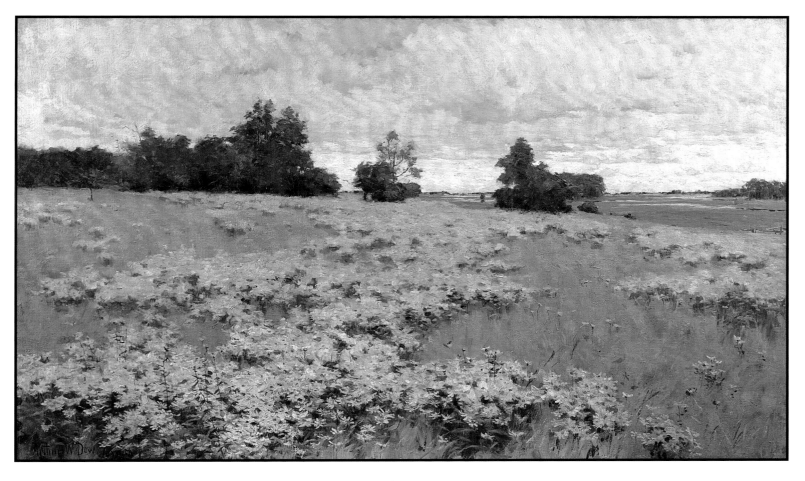

26. **Arthur Wesley Dow** (1857–1922)
Frost Flowers, Ipswich, Massachusetts, 1889, oil on canvas, 33 × 55½ inches,
signed and inscribed lower left: *Arthur W. Dow Ipswich*;
signed, dated and inscribed verso: *Arthur W. Dow/Ipswich, Mass 1889*

(See cover for an enlarged detail)

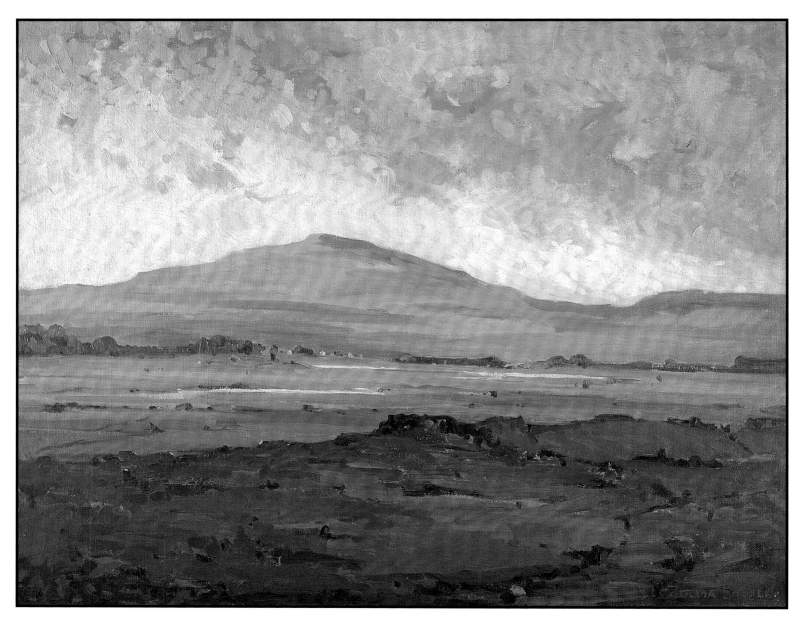

27. **Zulma Steele** (1881–1979)
West Hurley Clearing—Ashokan Reservoir, ca. 1915, oil on canvas, 24 × 30 inches,
signed lower right: *Zulma Steele*; also signed, titled and inscribed verso:
West Hurley Clearing – Ashokan Resevoir/Zulma Steele Woodstock NY

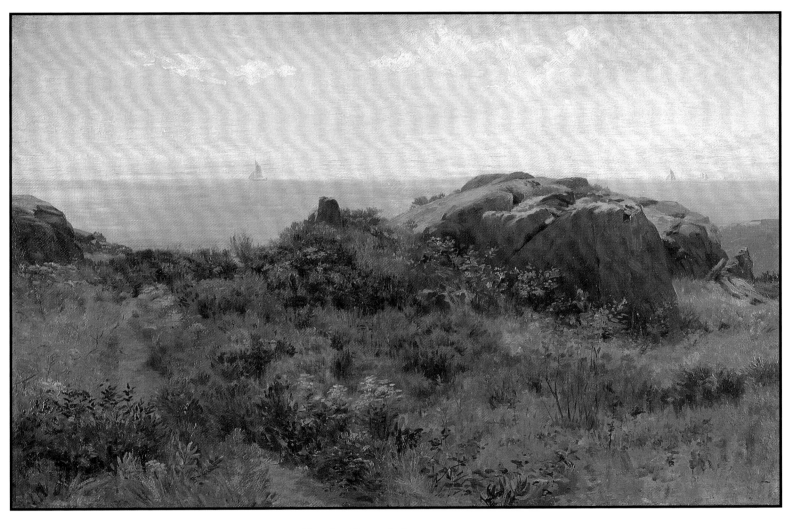

28. **Charles Francis Browne** (1859–1920)
Sunny Morning, Cape Ann, Massachusetts, ca. 1890s–1910, oil on canvas, 16 × 24 inches,
signed lower right: *C. F. Brown*; also signed and titled verso:
Sunny Morning, Cape Ann, Mass/Charles Francis Browne

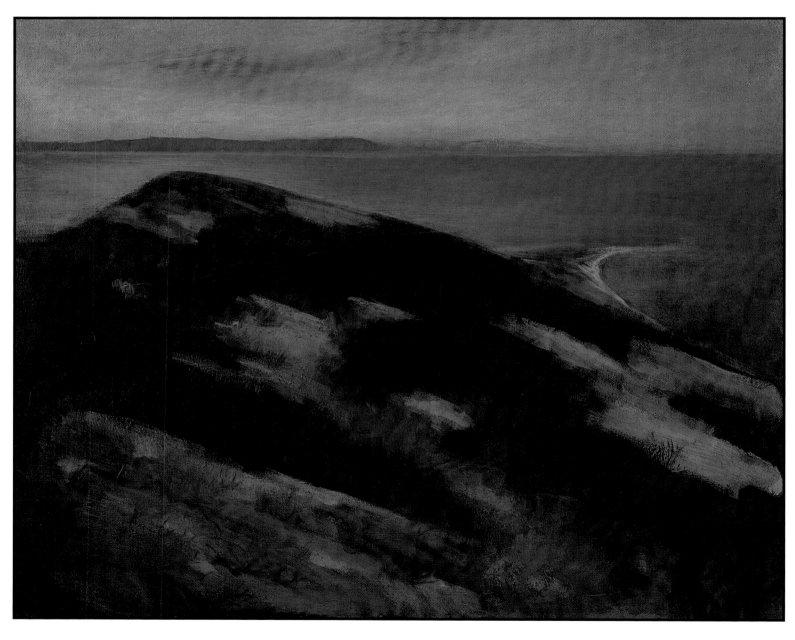

29. **Edith Mitchill Prellwitz** (1864–1944)

Beach Scene, Long Island, New York, ca. 1920s, oil on canvas, 18 × 22 inches

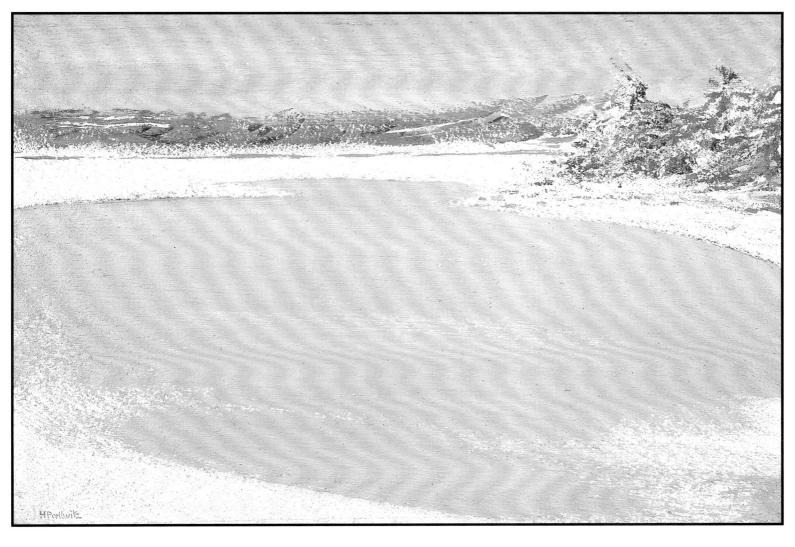

30. **Arthur Henry Prellwitz** (1865–1940)

Frozen Inlet, Richmond Creek, Peconic, Long Island, New York, ca. mid-1910s–20s,
oil on board, 9⅛ × 13⅛ inches, signed lower left: *H. Prellwitz*

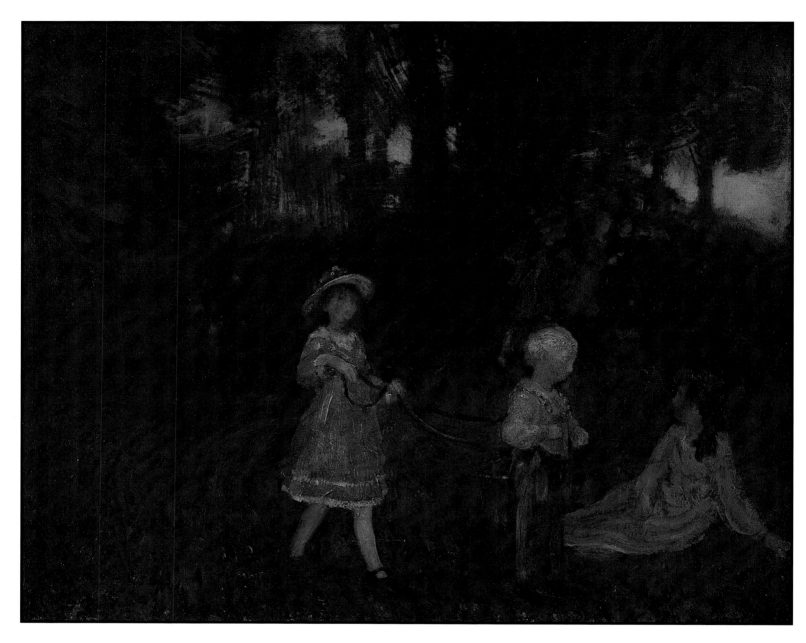

31. **Arthur B. Davies** (1862–1928)
Children Playing, ca. 1896, oil on canvas, 18 × 22 inches,
signed lower left: *A. B. Davies*

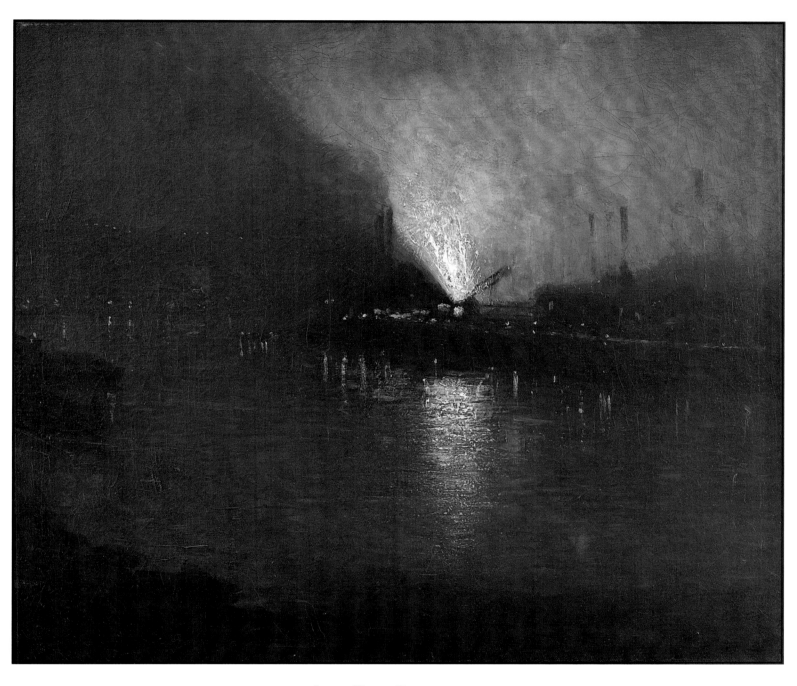

32. **Aaron Harry Gorson** (1872–1933)
Steel Mills—Nocturne, Pittsburgh, ca. 1903–20, oil on canvas, 27 × 31 inches

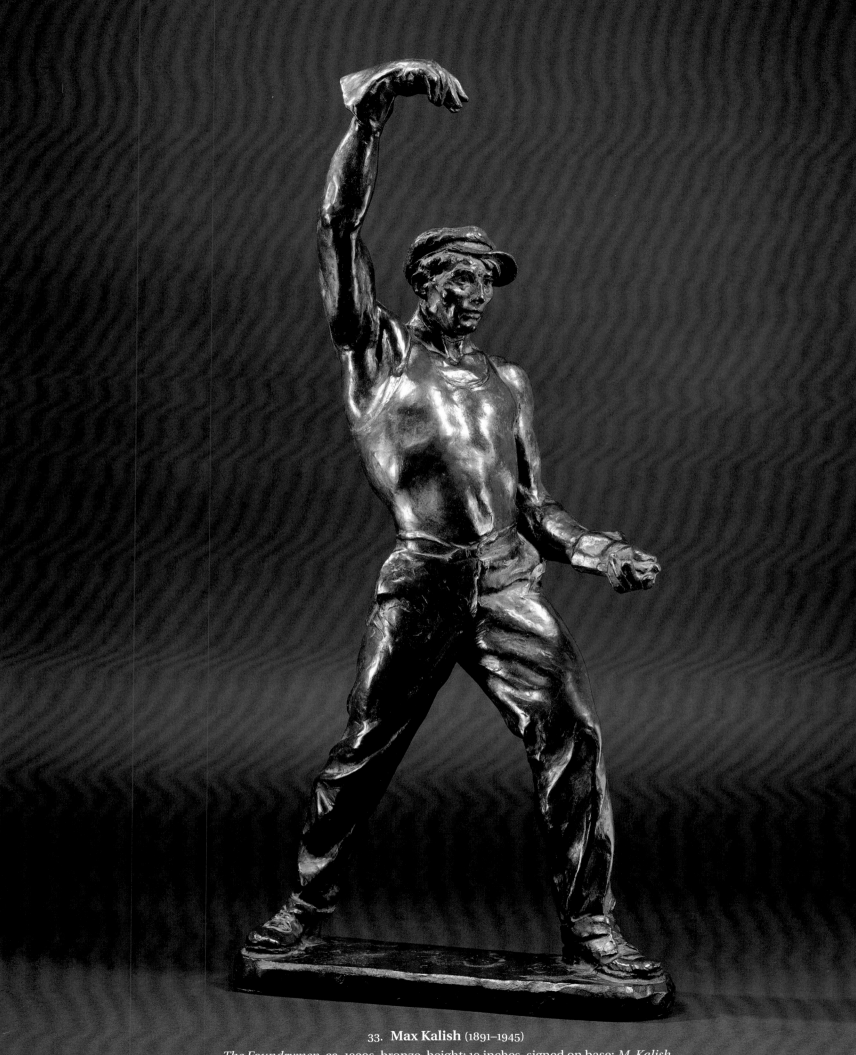

33. Max Kalish (1891–1945)
The Foundrymen, ca. 1920s, bronze, height: 19 inches, signed on base: *M. Kalish*

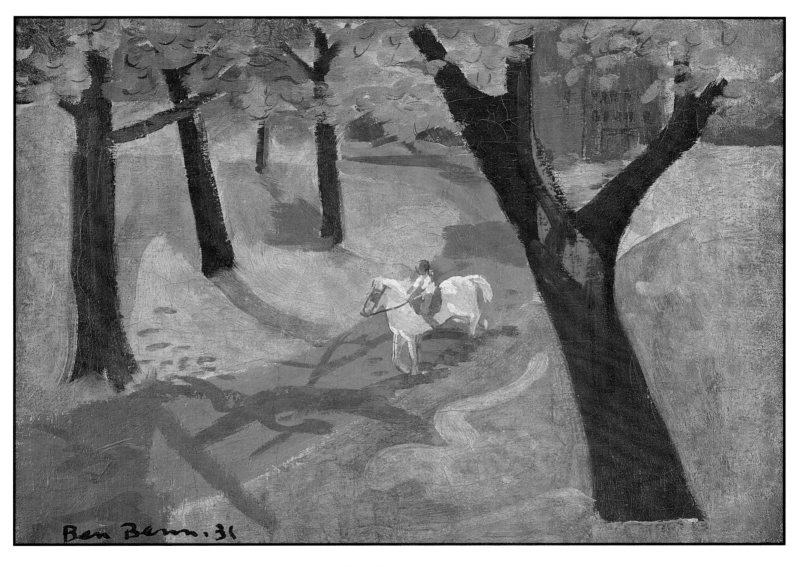

34. **Ben Benn** (1884–1983)

The White Horse, 1931, oil on canvas, 13 × 18 inches,
signed and dated lower left: *Ben Benn '31*

35. **Annie G. Sykes** (1855–1931)
The Yellow House, ca. 1890, watercolor on paper, 22 × 15 inches

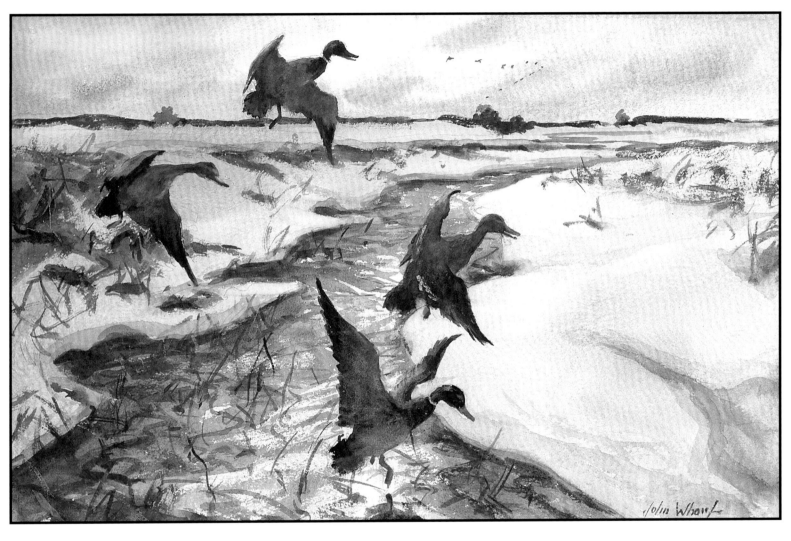

36. John Whorf (1903–1959)
Ducks in Flight, ca. 1920s–30s, watercolor on paper, 14¾ × 28¾ inches,
signed lower right: *John Whorf*

37. **Chauncey F. Ryder** (1868–1949)
Spring Landscape, ca. 1910s, oil on board, 12 × 16 inches,
signed lower left: *Chauncey F Ryder*

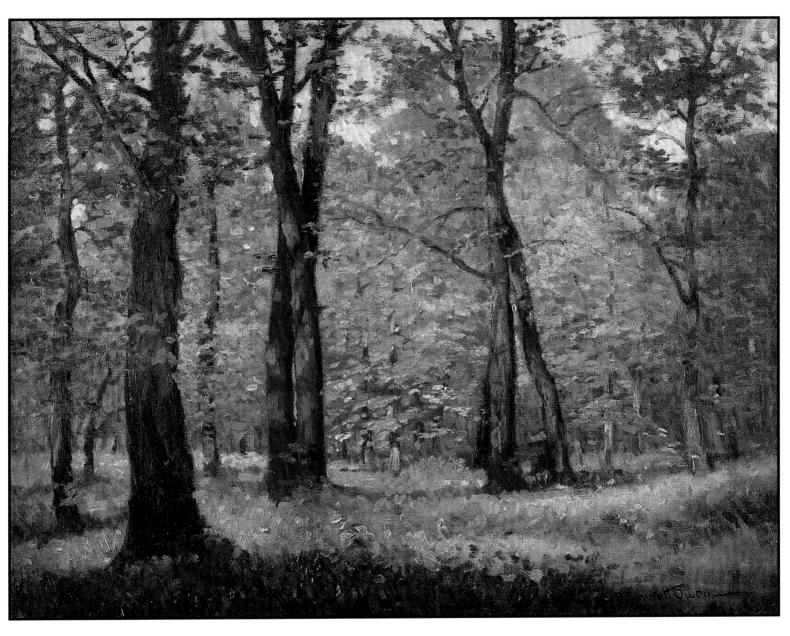

38. Robert Emmett Owen (1878–1957)

Study at Fort Lee, New Jersey, ca. 1900–10, oil on canvas, 16 × 20 inches,
stamped with the artist's estate stamp lower right: *R. Emmett Owen*

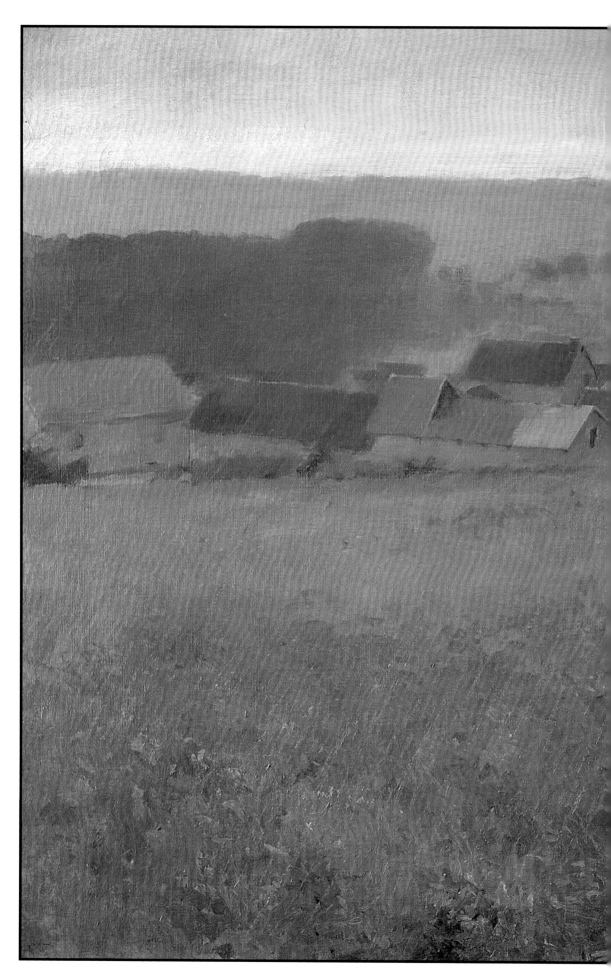

39. **William Blair Bruce** (1859–1906)
Rain in Giverny, France, 1887, oil on canvas, 27 × 36 inches,
signed and dated lower right: *Blair Bruce 87*

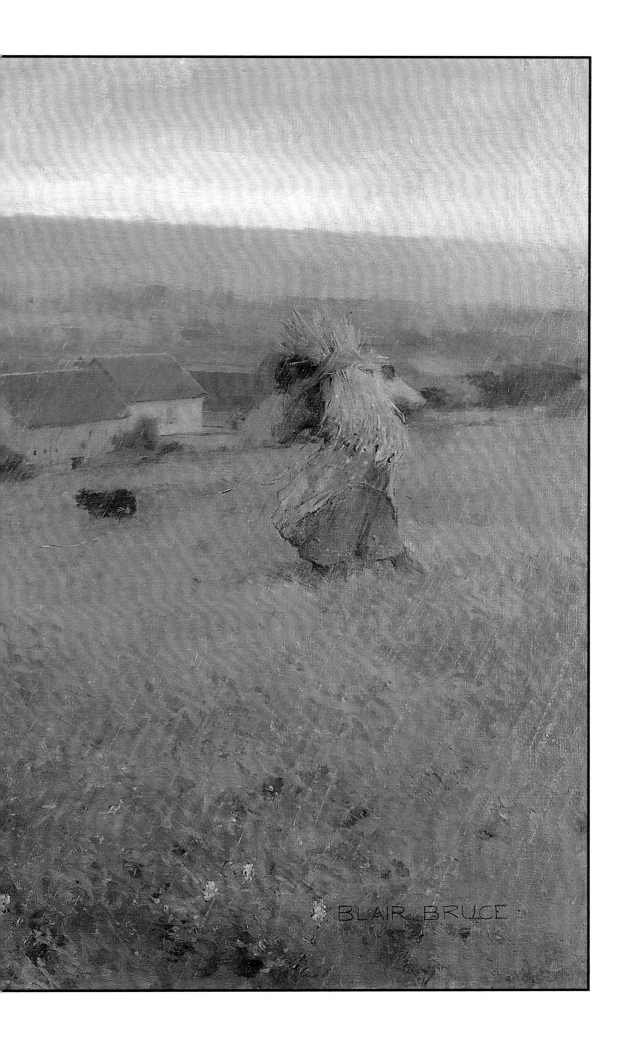

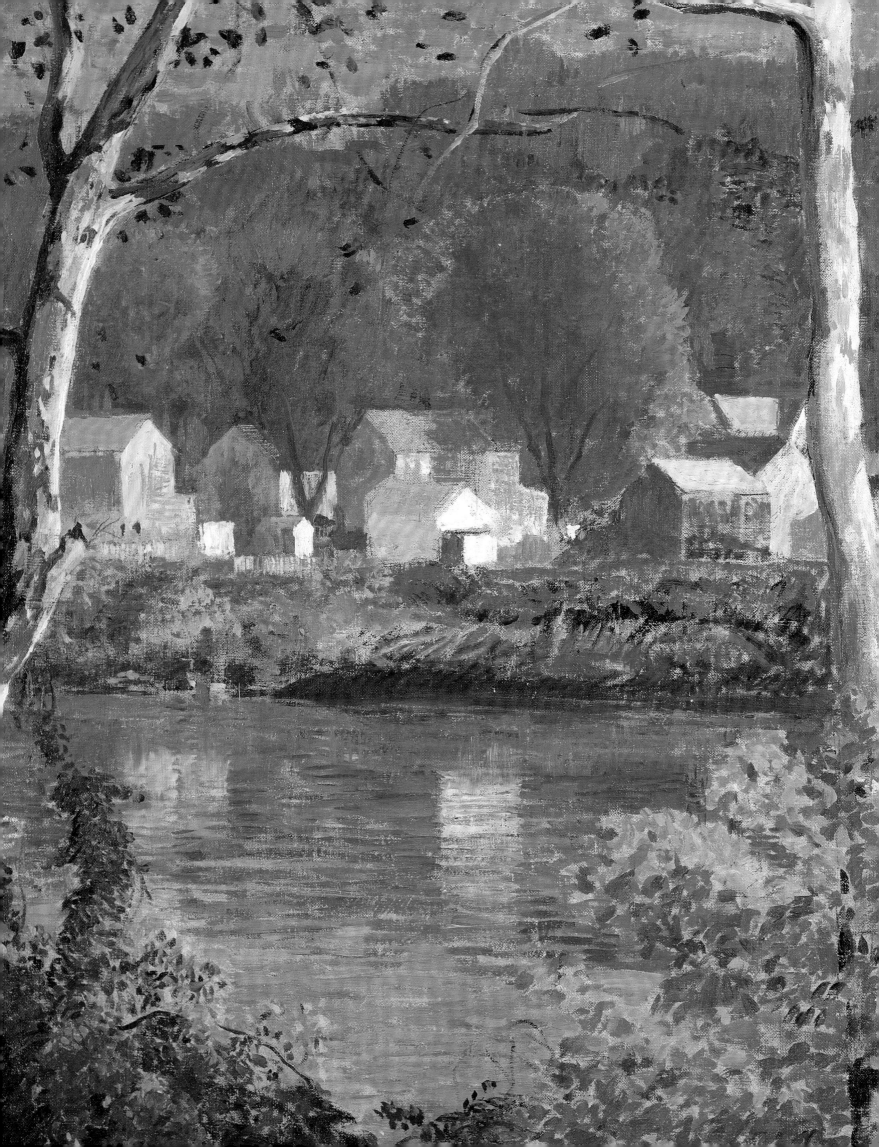

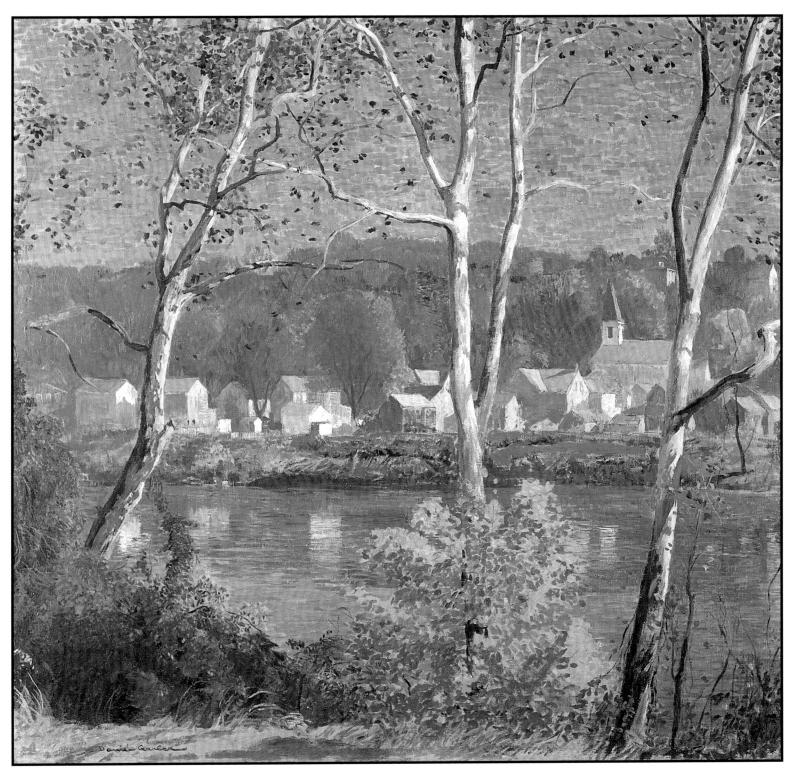

40. **Daniel Garber** (1880–1958)

October—Frenchtown, New Jersey, 1939, oil on canvas, 29½ × 29½ inches,
signed lower left: *Daniel Garber*

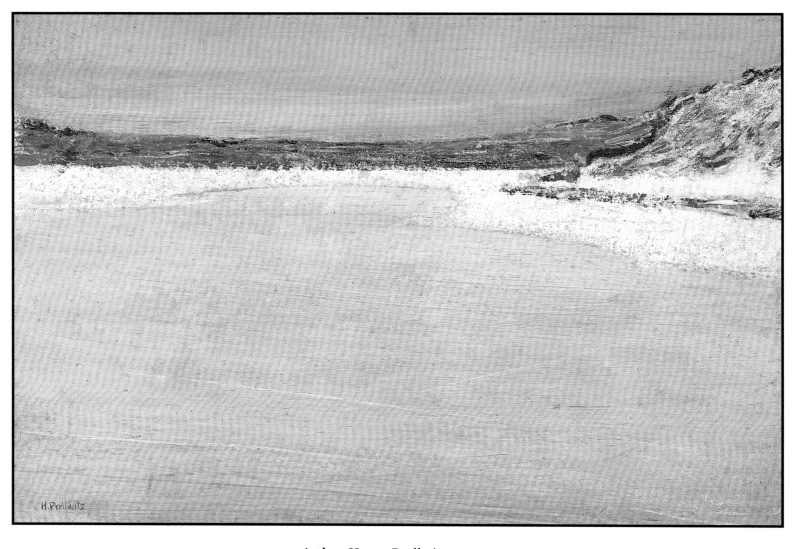

41. **Arthur Henry Prellwitz** (1865–1940)
Pond in Winter, Richmond Creek, Peconic, Long Island, New York, ca. mid-1910s–20s,
oil on board, 9 × 13 inches, signed lower left: *H. Prellwitz*

42. **Hyman Francis Criss** (1901–1973)
Morning in Florence, 1934, oil on canvas, 24 × 33 inches,
signed lower right: *Criss*

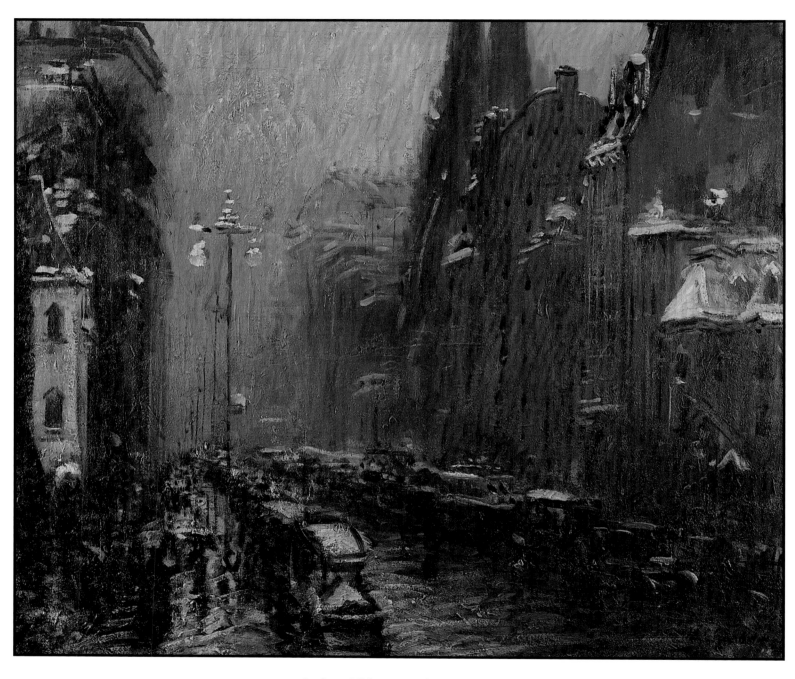

43. Arthur Clifton Goodwin (1866–1929)
Fifth Avenue, New York City, ca. 1920, oil on canvas, 30¼ × 35¼ inches,
signed lower right: *A. C. Goodwin*

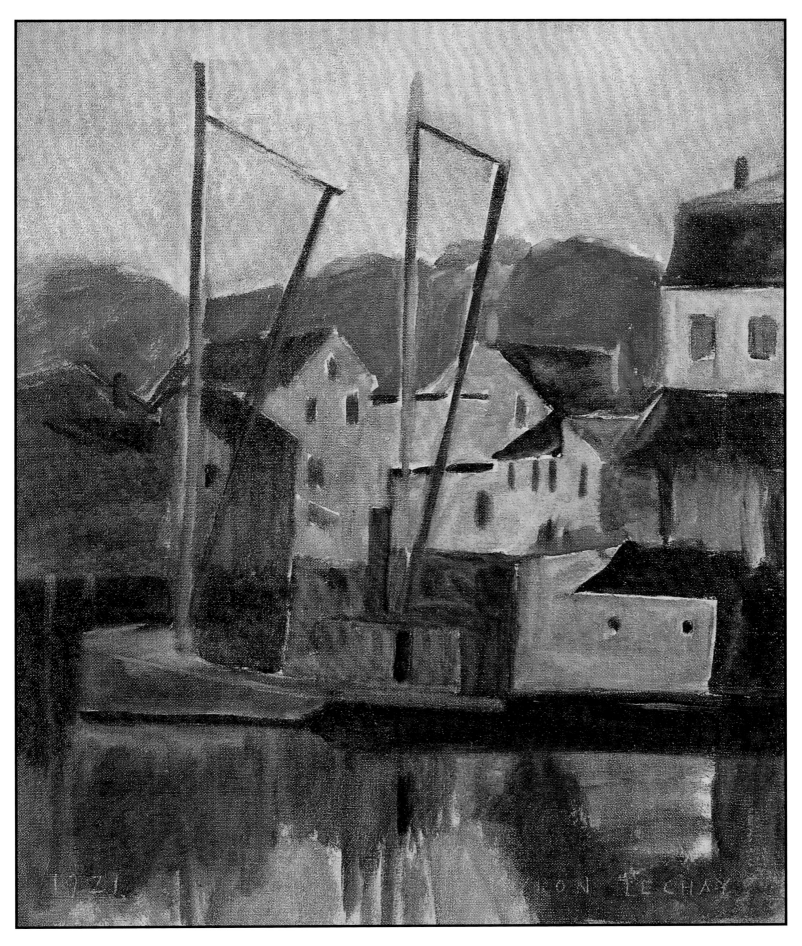

44. **Myron Lechay** (1898–1972)
Fishing Boats at Port, Gloucester, Massachusetts, 1921, oil on canvas, 24 × 20 inches,
signed lower right: *Myron Lechay;* dated lower left: *1921*

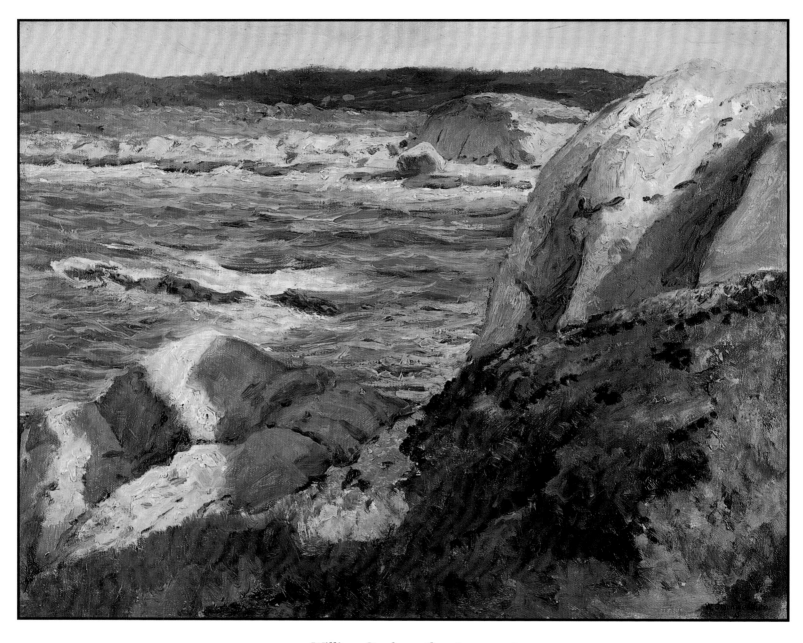

45. **William Starkweather** (1879–1969)
The Inlet Painted at Peggy's Cove, Nova Scotia, Canada, 1948, oil on canvasboard, 16 × 20 inches,
signed lower right: *W. Starkweather*; also signed, dated and titled verso:
The Inlet Painted at Peggy's Cove, N.S., Canada 1948 by William Starkweather

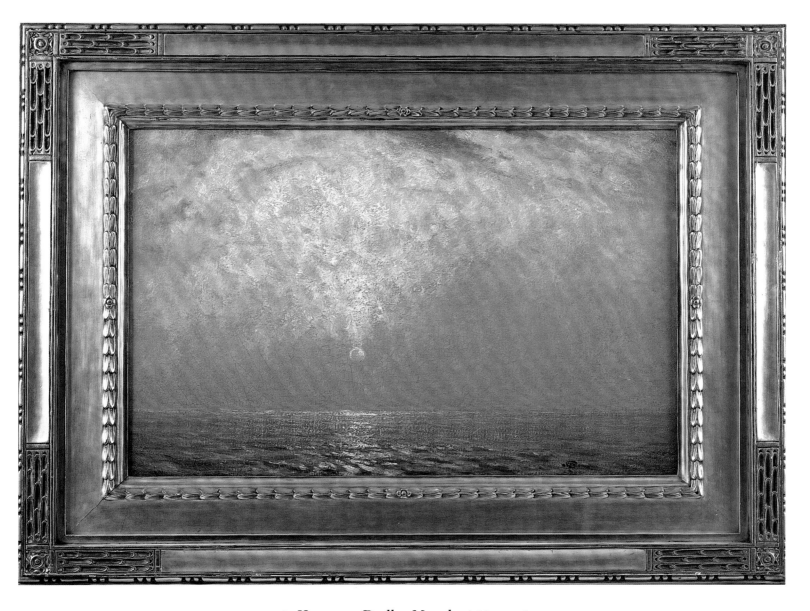

46. **Hermann Dudley Murphy** (1867–1945)

Sunrise (*Seascape with Rising Sun*), ca. 1910, oil on canvas, 20 × 30 inches,

signed with monogrammed initials lower right: *HDM*;

also signed, titled and inscribed verso: *Hermann Dudley Murphy "Sunrise"/Winchester, Mass*

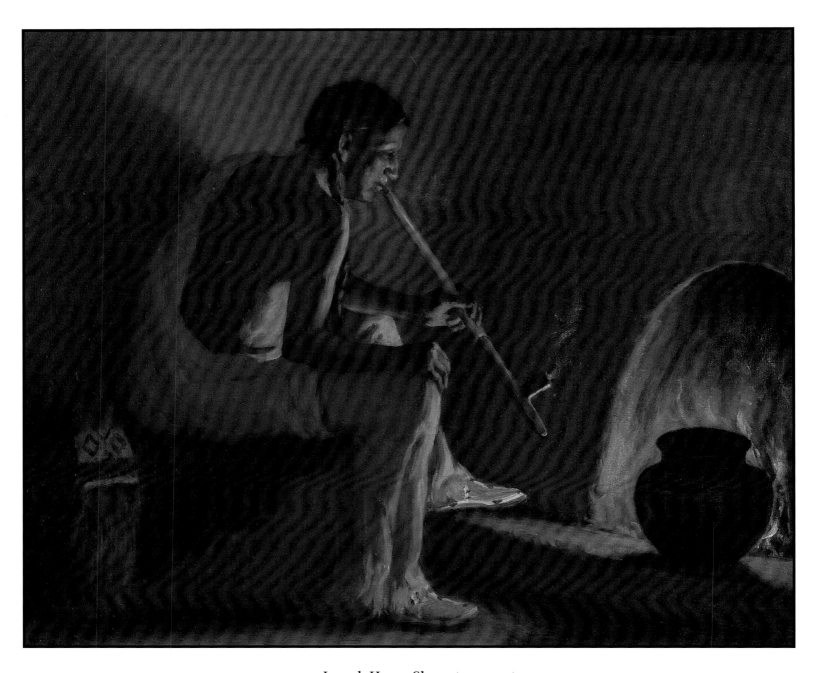

47. Joseph Henry Sharp (1859–1953)

Hunting Son—Taos Indian, Son of Soaring Eagle, ca. 1932–33, oil on canvas, 20 × 24 inches,

signed lower left: *JH Sharp*; also signed, dated and inscribed verso: *"Hunting Son" – Taos Indian/Son of "Soaring Eagle"*

A great hunter/Painted 3 to 4 years ago/J. H. Sharp/Taos, Aug. 1936

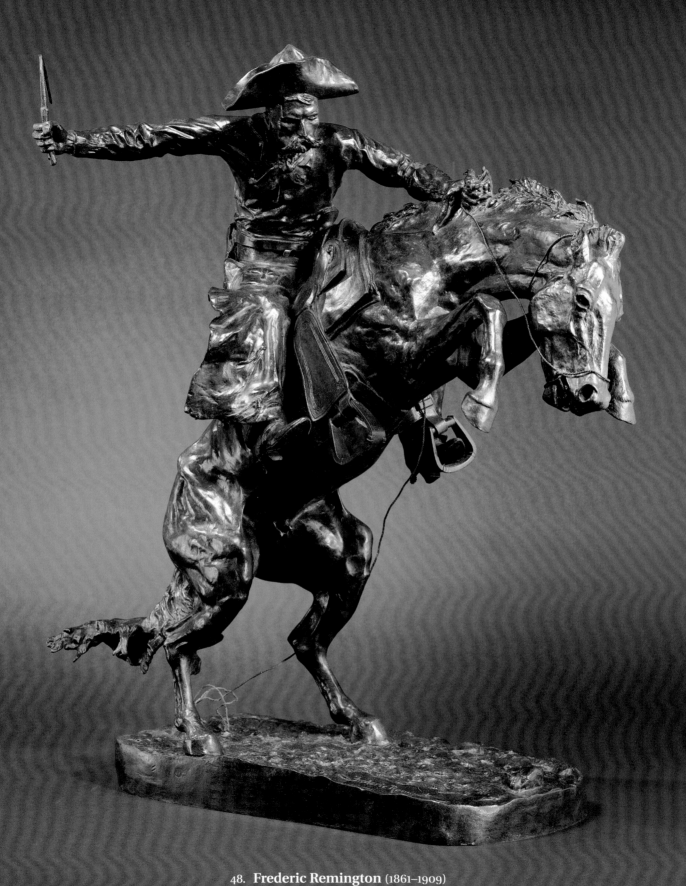

48. **Frederic Remington** (1861–1909)

Bronco Buster, Henry Bonnard Cast No. 22, 1895, bronze, 23 × 19 × 13 inches, signed *Frederic Remington* and stamped with the foundry mark *CAST BY THE HENRY BONNARD BRONZE CO. N-Y 1895* on the top of the base; numbered *R22* underneath the base; signed, dated, and inscribed © *by Frederic Remington 1895* on side of base

49. Eric Pape (1870–1938)
Seascape, 1929, oil on canvas, 10¾ × 20½ inches,
signed and dated lower right: *Eric Pape 1929*

50. Margaret Jordan Patterson (1868/9–1950)
Italian Mountain View, ca. 1910s–30s, oil on canvas, 15¼ × 18¼ inches,
stamped with the artist's estate stamp verso

51. **Jay Hall Connaway** (1893–1970)
Monhegan Coast, Maine, 1933, oil on panel, 18 × 30 inches,
signed and dated lower right: *Connaway 33*

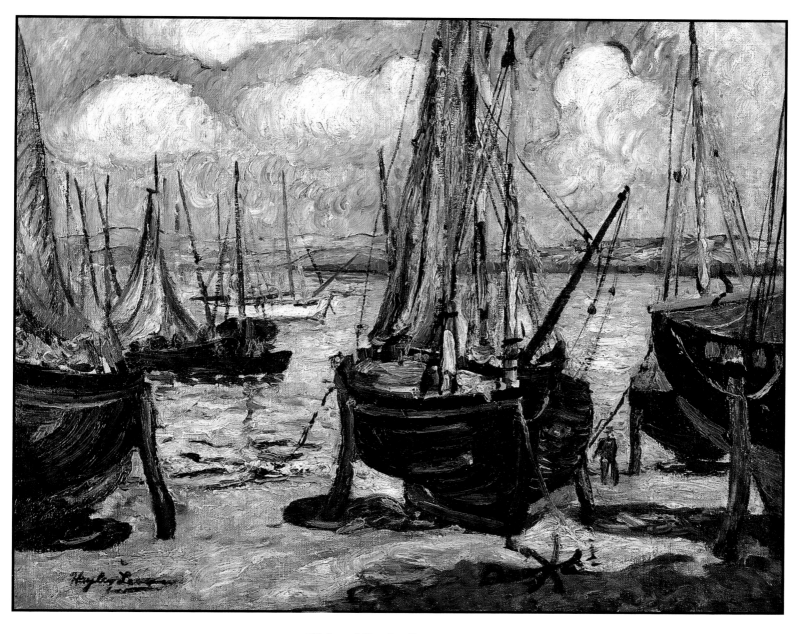

52. **Richard Hayley Lever** (1876–1958)
Boats in Dry Dock, ca. 1920s–30s, oil on canvas, 16 × 20 inches,
signed lower left: *Hayley Lever*

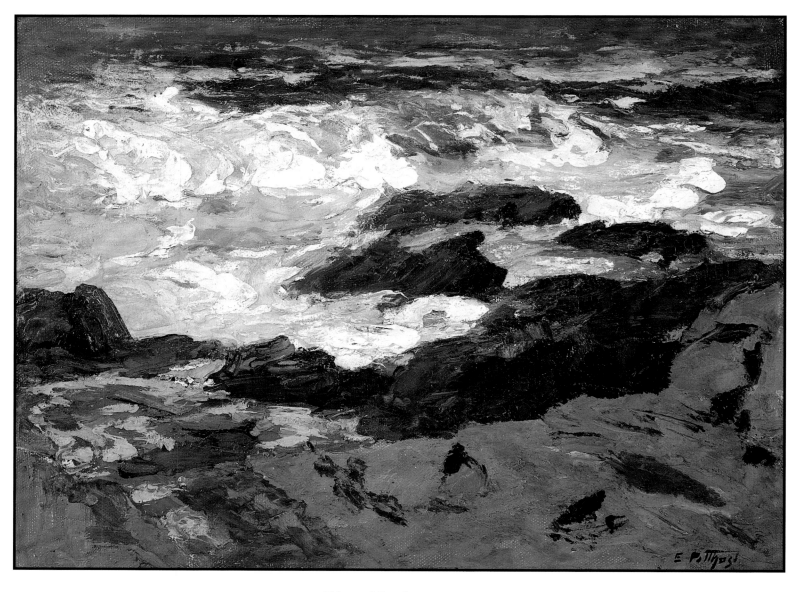

55. Edward Potthast (1857–1927)
Wild Surf, Ogunquit, Maine, ca. 1910s, oil on canvasboard, 12 × 16 inches,
signed lower right: *E. Potthast*

56. **Charles Salis Kaelin** (1858–1929)

Boats in Winter, Rockport, Massachusetts, ca. 1910s–20s, oil on canvas, 29⅛ × 28 inches

57. **Willard Leroy Metcalf** (1858–1925)
Mountain Lakes, Olden, Norway, 1913, oil on canvas, 18¼ × 21½ inches,
signed, dated and dedicated lower right: *To my friend Frederic Norton / W. L. Metcalf 1913*

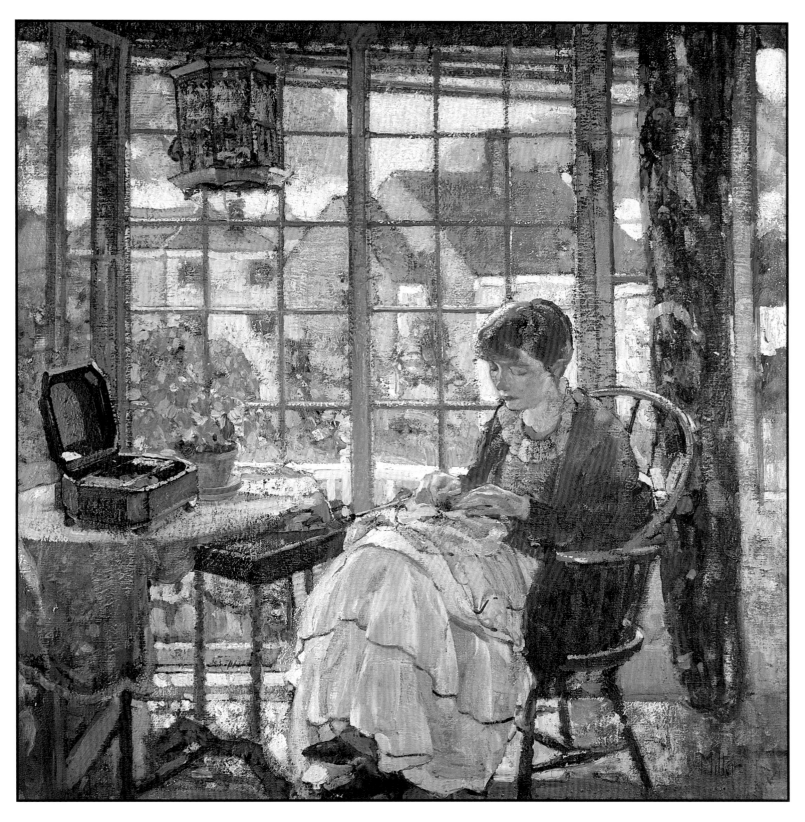

58. **Richard Miller** (1875–1943)
Woman Sewing, ca. 1927, oil on canvas, 36 × 34 inches,
signed lower right: *Miller*

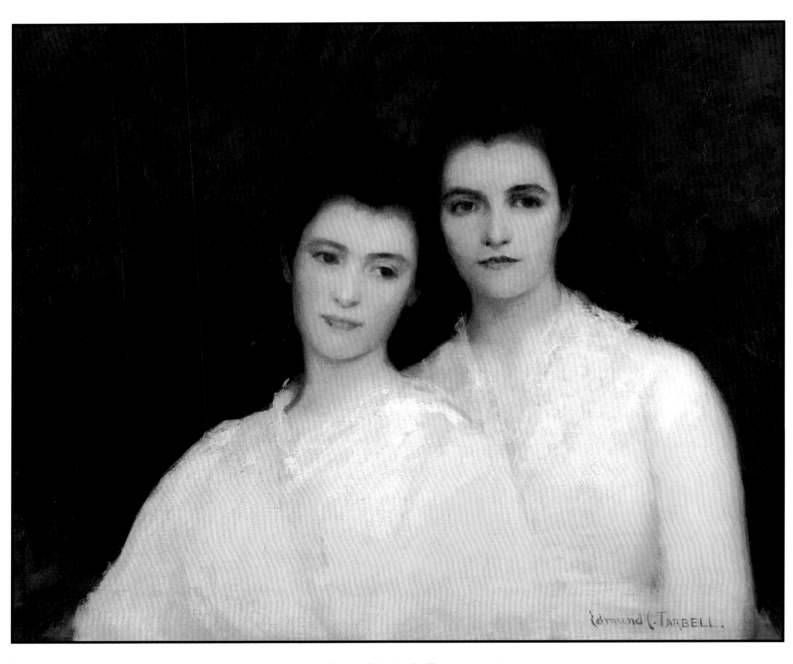

59. Edmund C. Tarbell (1862–1938)
Emeline and Josephine Tarbell (The Artist's Wife and Daughter), ca. 1905, oil on canvas, 26 × 36 inches,
signed lower right: *Edmund C. Tarbell*

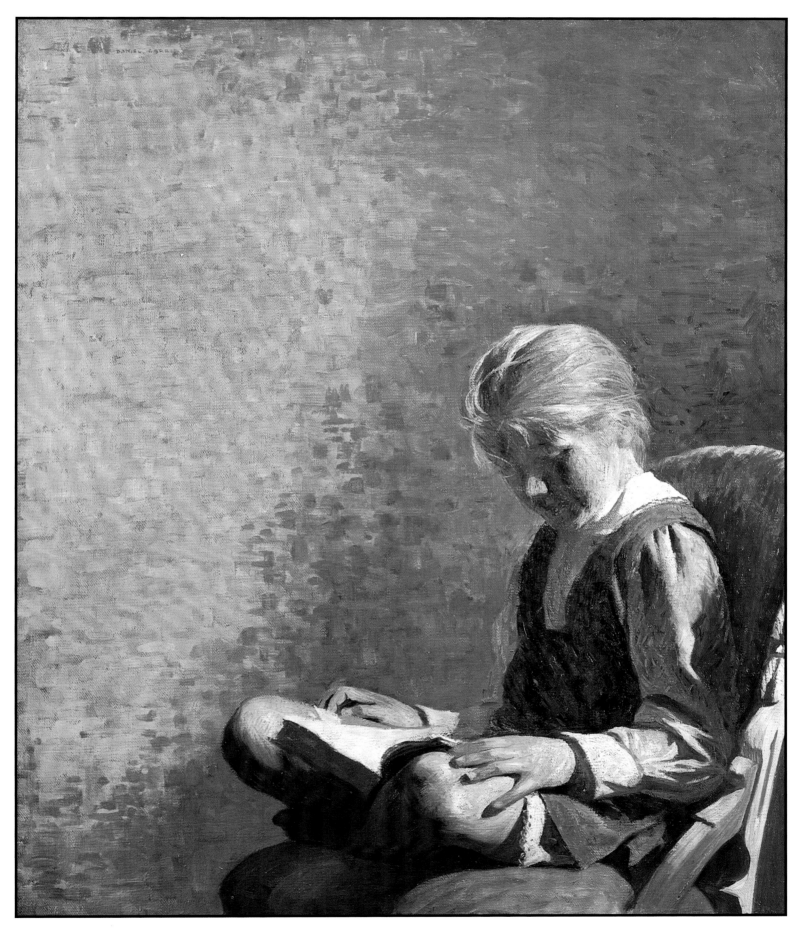

60. **Daniel Garber** (1880–1958)
The Fairy Tale (Tanis Seated), ca. 1917, oil on canvas, 30¼ × 25¼ inches,
signed upper left: *Daniel Garber*

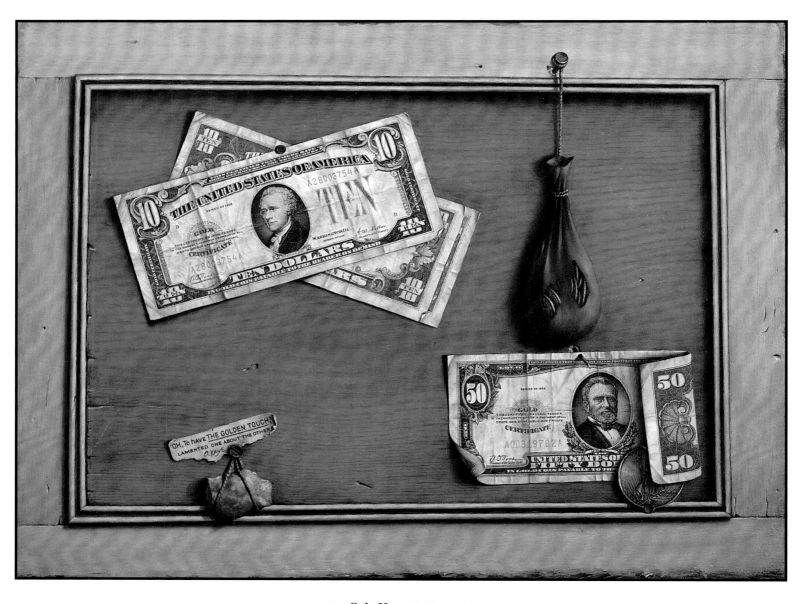

61. **Otis Kaye** (1885–1974)
The Golden Touch, 1928, oil on panel, 12 × 16 inches,
signed and titled lower left: *'Oh, to Have The Golden Touch/ Lamented One About the Other/O. Kaye*;
dated upper left and center right: *1928*

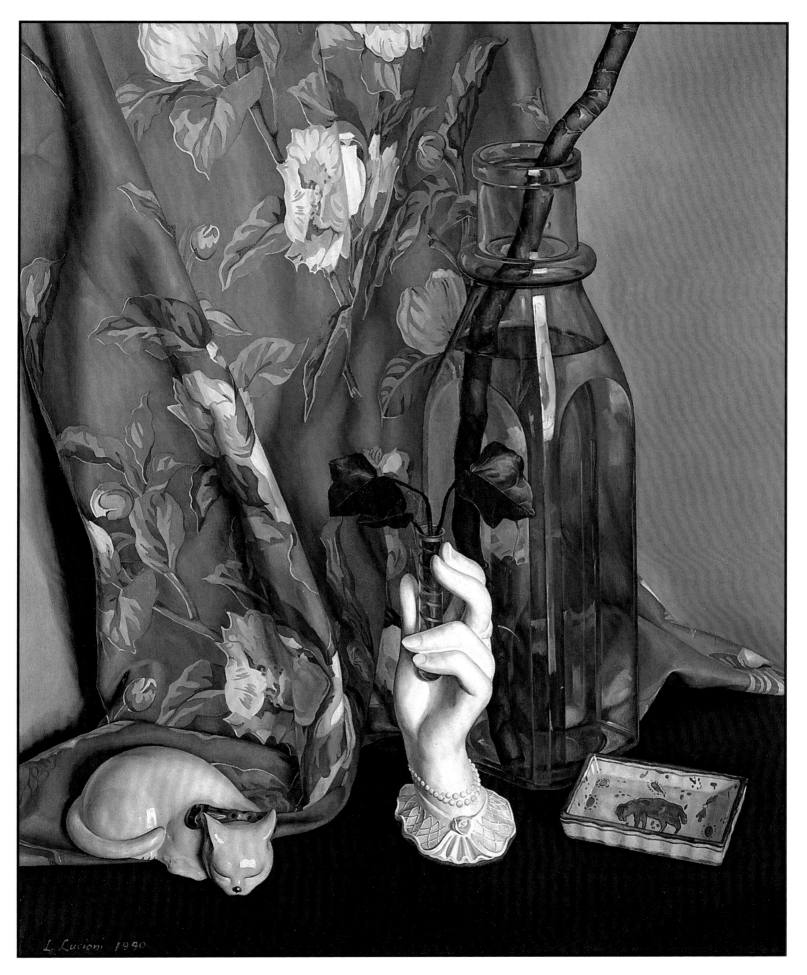

62. **Luigi Lucioni** (1900–1988)
Still Life, 1940, oil on canvas, 20¼ × 16¼ inches,
signed and dated lower left: *L. Lucioni 1940*

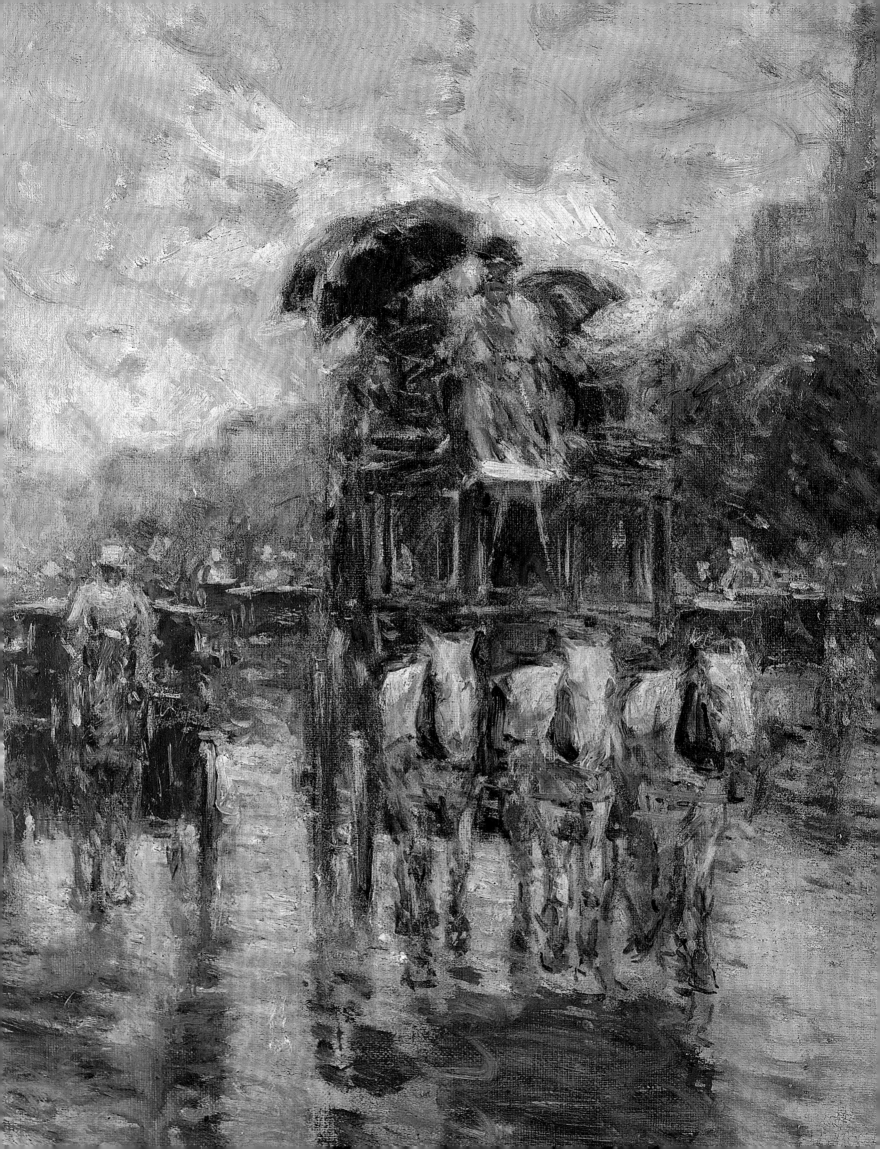

63. **Childe Hassam** (1859–1935)

Les Grands Boulevards, Paris, 1897, oil on canvas, 18 × 30 inches,
signed and dated lower left: *Childe Hassam 1897*;
also signed with the artist's monogrammed initials,
dated and titled verso: *CH 1897/ Les Grands Boulevards, Paris*

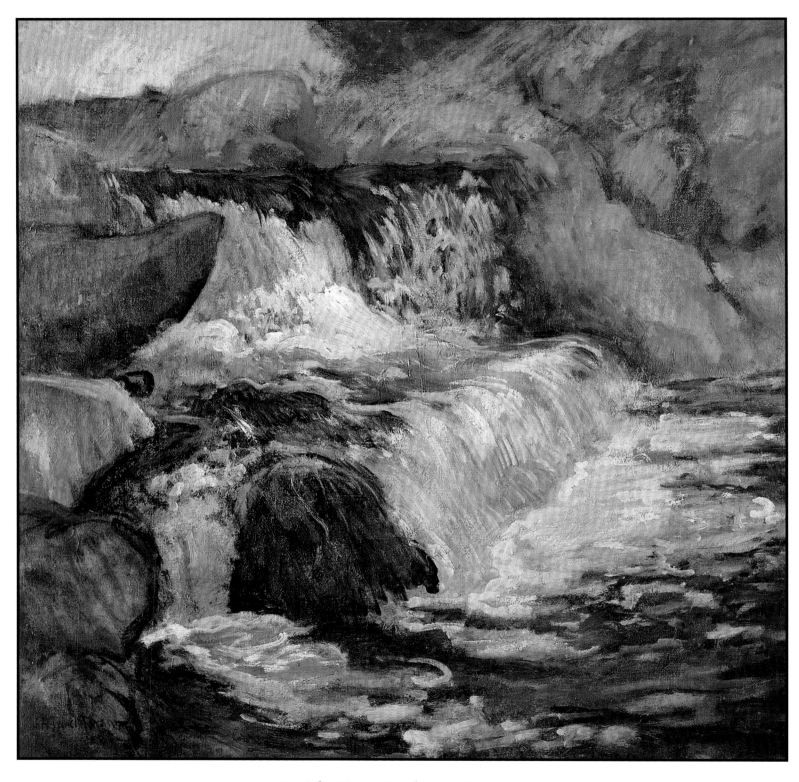

64. John Henry Twachtman (1853–1902)
The Cascade, Greenwich, Connecticut, ca. 1890s, oil on canvas, 30 × 30 inches,
signed lower left: *J. H. Twachtman*

(See frontispiece for an enlarged detail)

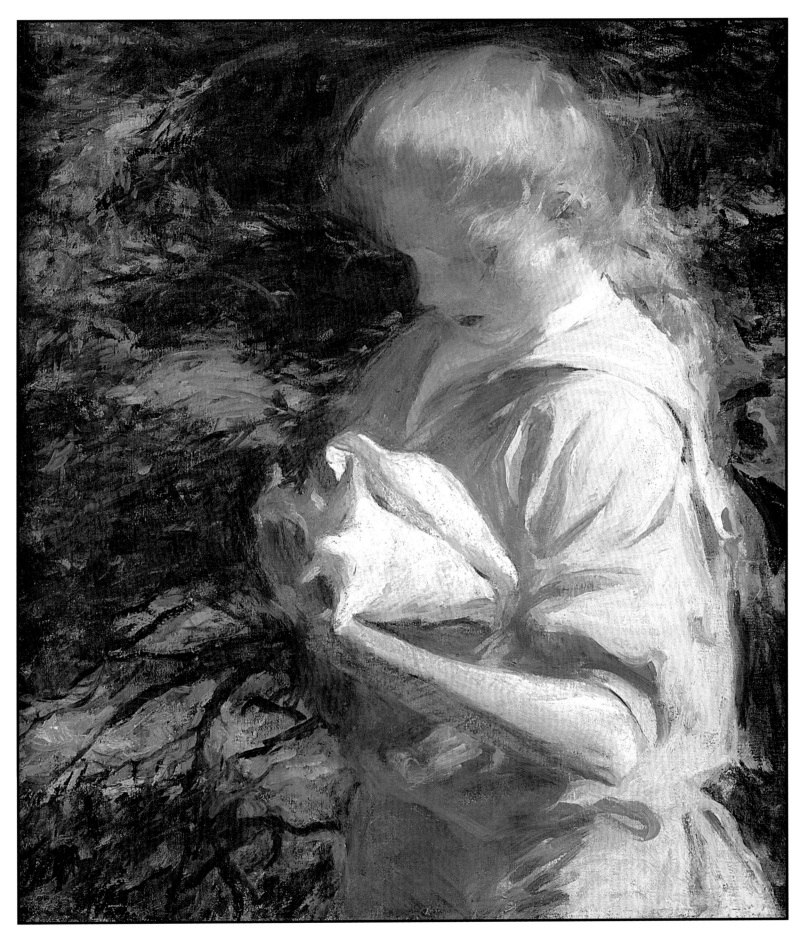

65. Frank W. Benson (1862–1951)
Eleanor Holding a Shell, North Haven, Maine, 1902, oil on canvas, 30¼ × 25 inches,
signed and dated upper left: *F. W. Benson, 1902*

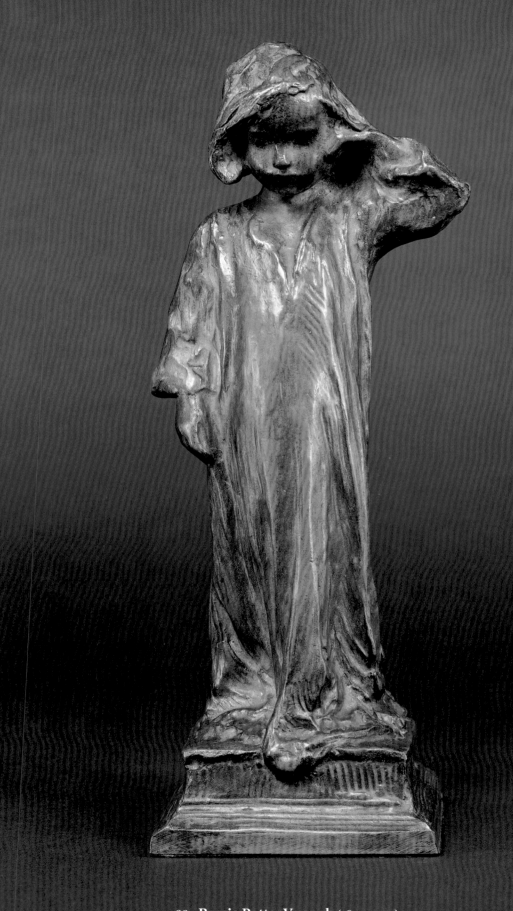

66. Bessie Potter Vonnoh (1872–1955)

Goodnight, ca. 1900, bronze, height: 9½ inches, signed on the base: *Bessie Potter Vonnoh*.;
stamped with the foundry mark on the base: *Gorham Co. Founders / QANV*; also stamped with cipher.

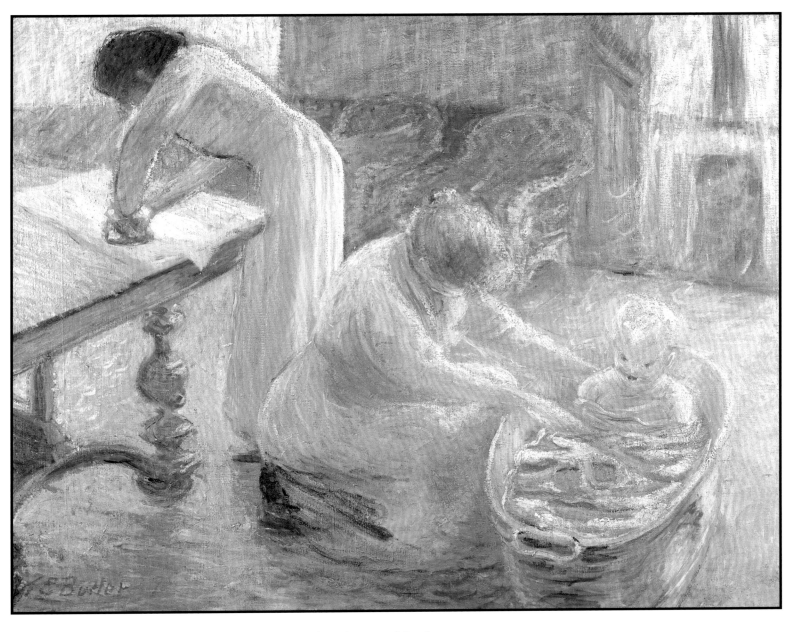

67. **Theodore Earl Butler** (1861–1936)

Le Bain, Maison Baptiste, Giverny, France, 1894, oil on canvas, 25½ × 32 inches,
signed and dated lower left: *T. E. Butler 94*

68. Childe Hassam (1859–1935)

Manhattan Sunset, 1911, oil on canvas, 19⅛ × 29⅞ inches, signed and dated lower left: *Childe Hassam* [illeg.] *1911*;
signed with monogrammed initials and dated verso: *CH 1911*

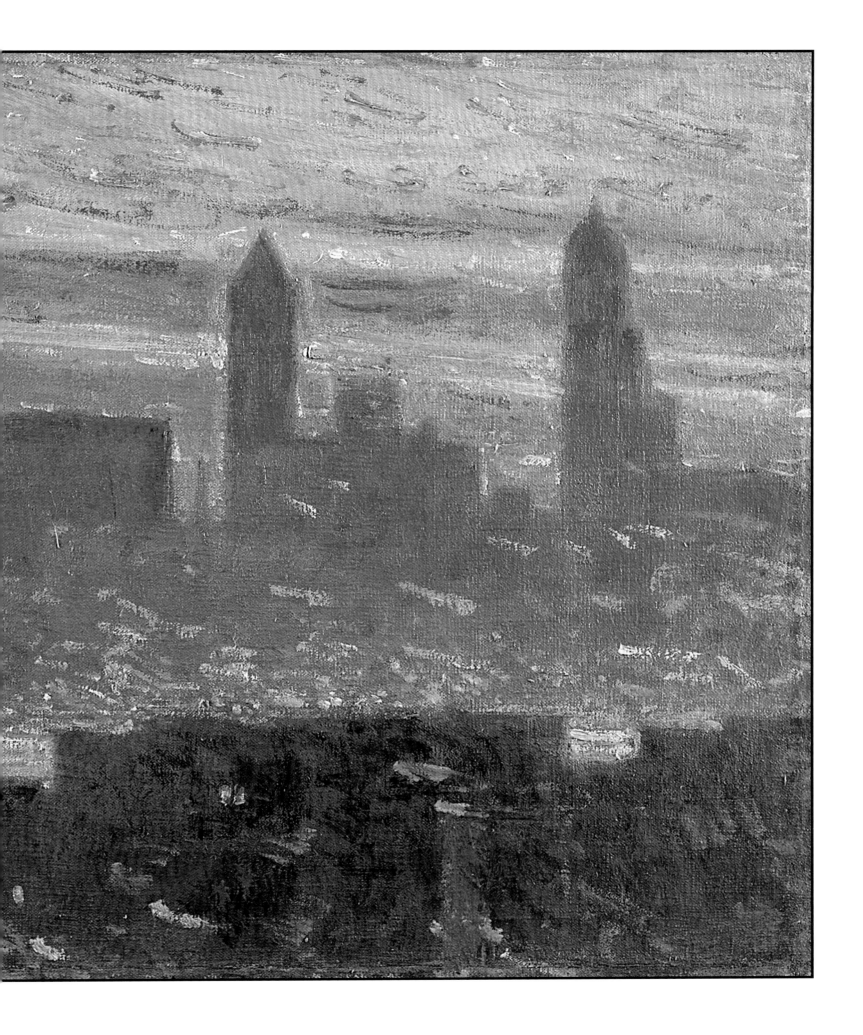

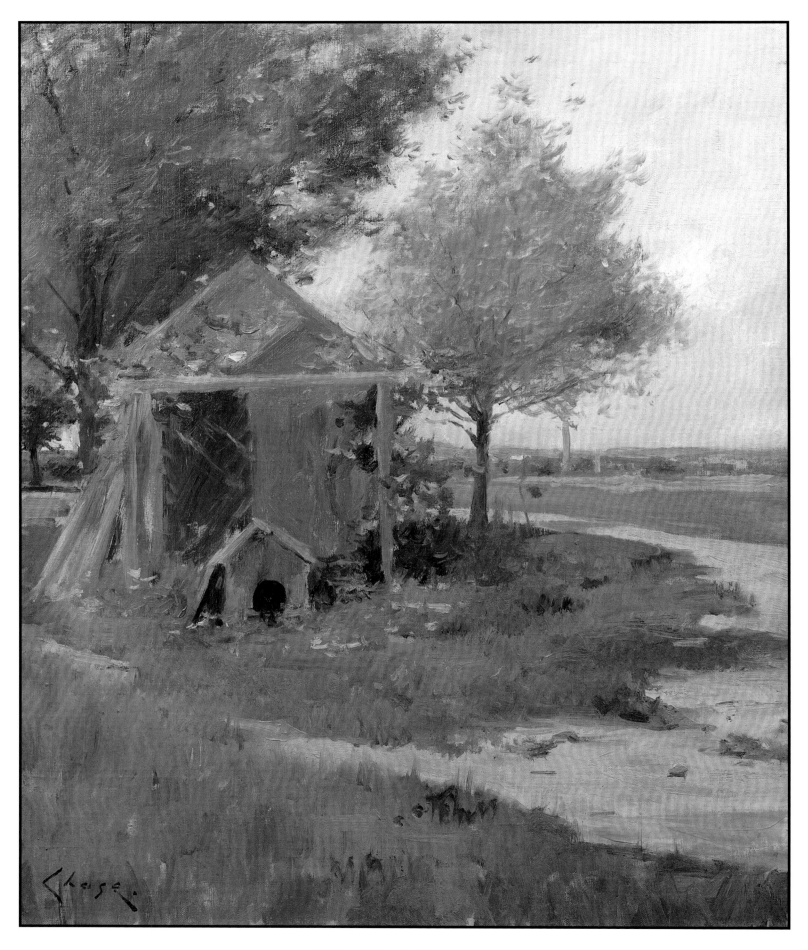

69. **William Merritt Chase** (1849–1916)
The Back Yard, Shinnecock, Long Island, New York, ca. 1900, oil on canvas,
30 × 25 inches, signed lower left: *Chase*

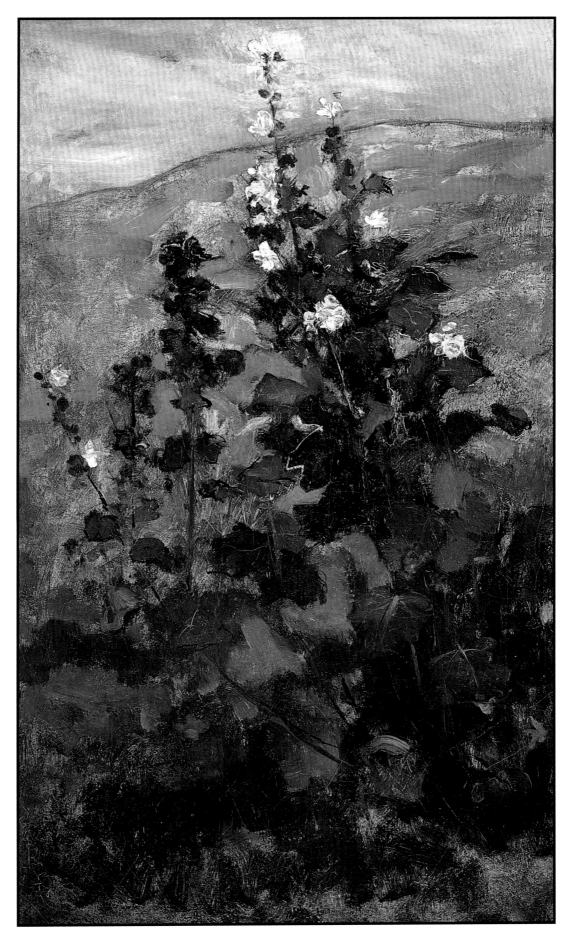

70. **John Henry Twachtman** (1853–1902)
Hollyhocks, ca. 1880s, oil on canvas, 24 × 14 inches,
signed verso: *Twachtman*

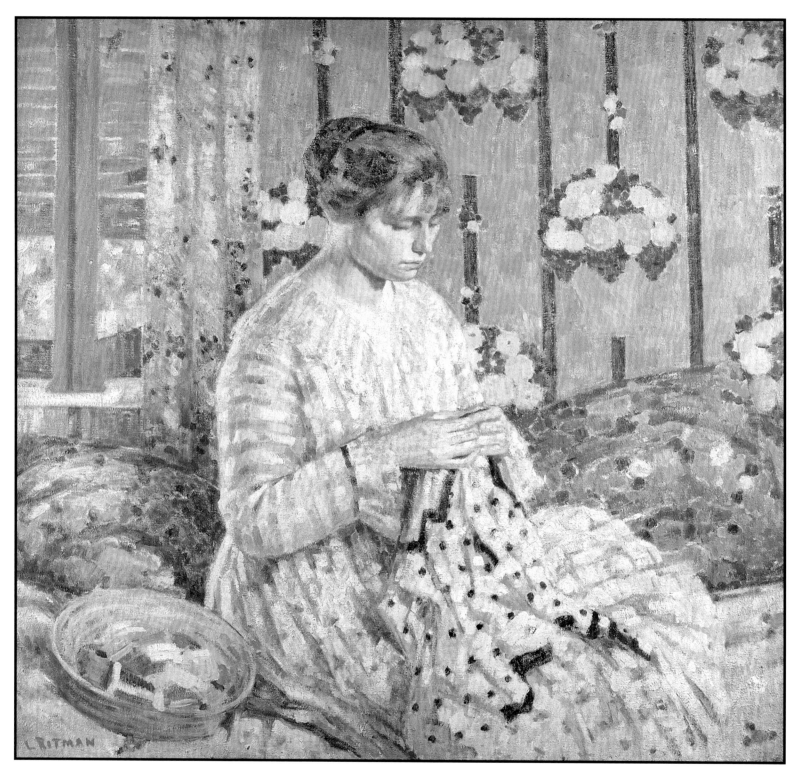

71. **Louis Ritman** (1889–1963)

Woman Sewing, ca. 1915, oil on canvas, 39½ × 39½ inches, signed lower left: *L. Ritman*

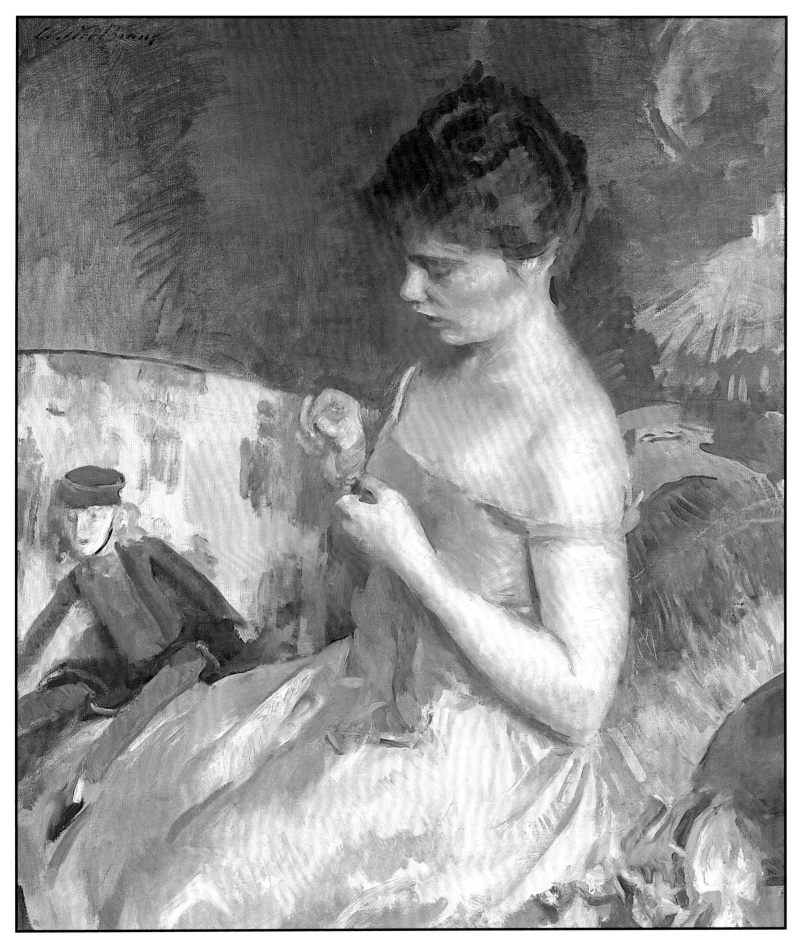

72. **Cecilia Beaux** (1855–1942)

Dressing Dolls, 1928, oil on canvas, 35⅝ × 29⅛ inches, signed upper left: *Cecilia Beaux*

73. **Robert Reid** (1862–1929)
Springtime, ca. 1900, oil on canvas, 26¼ × 29¼ inches,
signed lower left: *Robert Reid*

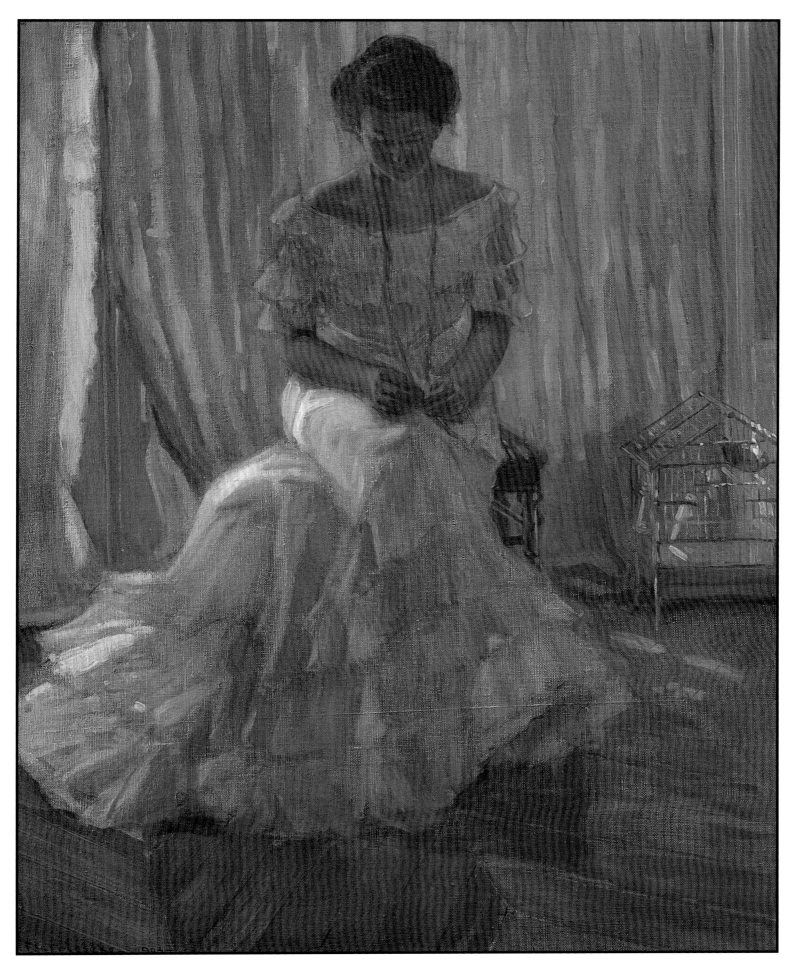

74. **Frederick Frieseke** (1874–1939)
Medora Clark at the Clark Apartment, Paris, 1903, oil on canvas, 32 × 25½ inches,
signed and dated lower left: *F. C. Frieseke 1903*

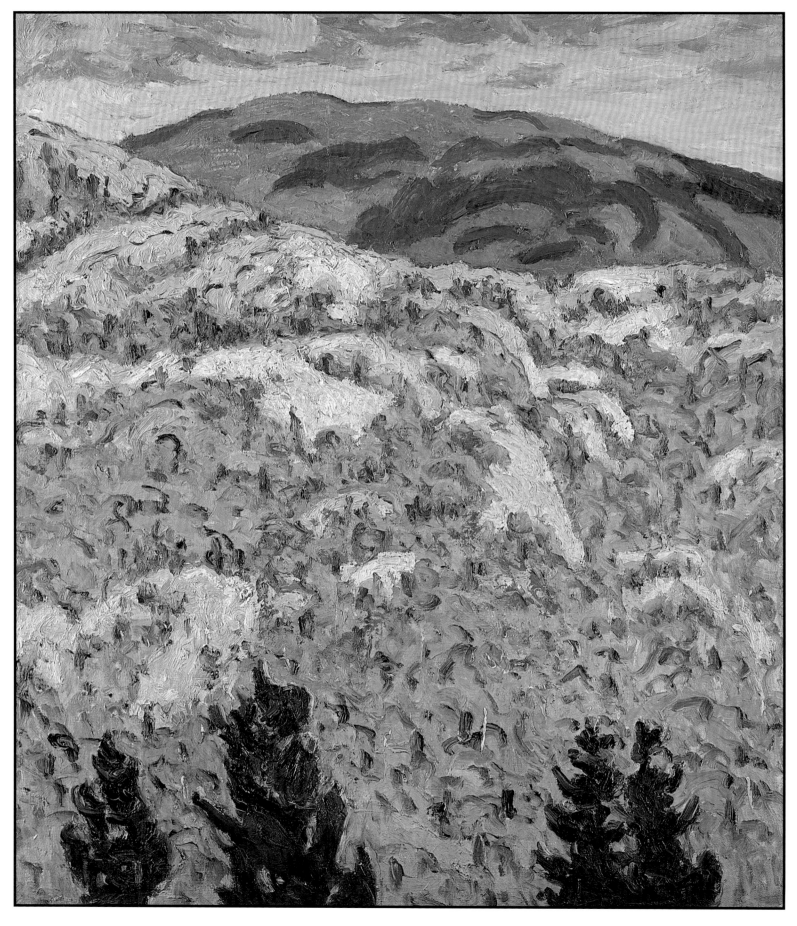

75. **Allen Tucker** (1866–1939)
Mountain Landscape, ca. 1911–16, oil on canvas, 36 × 24 inches

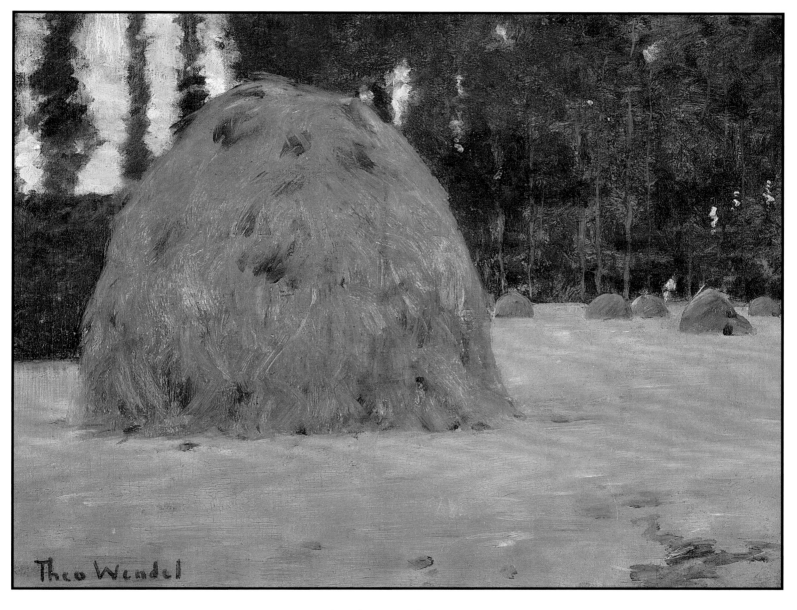

76. **Theodore Wendel** (1859–1932)
Haystacks in Giverny, France, ca. 1888, oil on canvas, 14½ × 18½ inches,
signed lower left: *Theo Wendel*

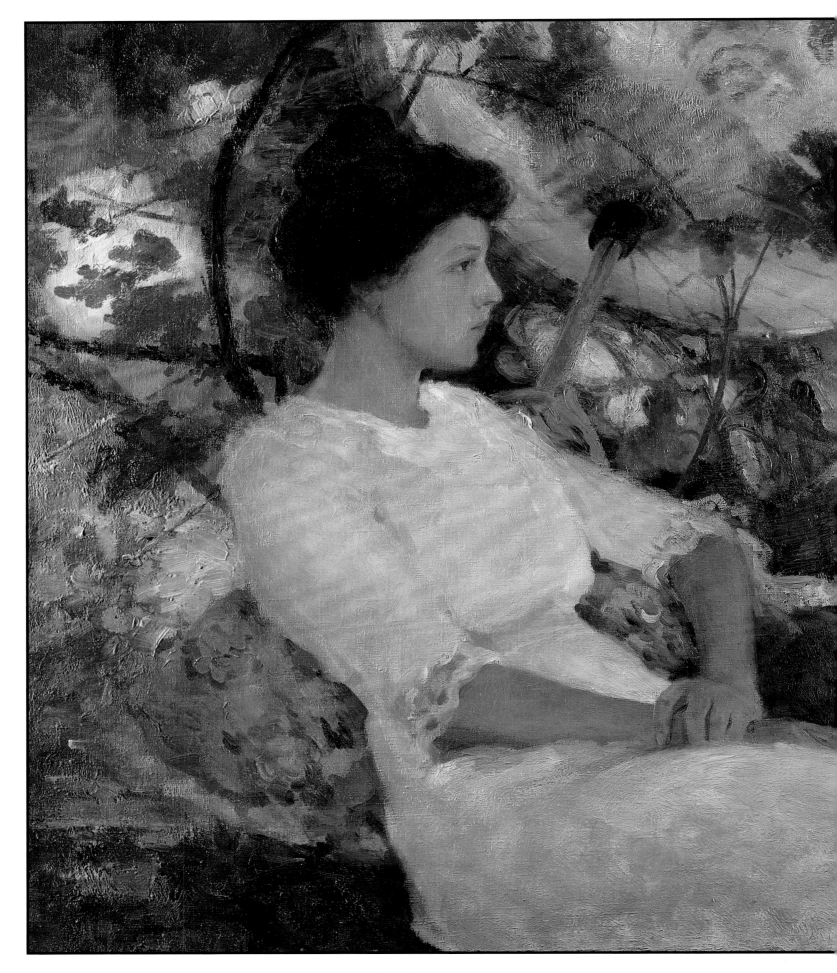

77. **Karl Buehr** (1866–1952)

In Repose, ca. 1915, oil on canvas, 30 × 36 inches, inscribed verso: *Grace McClary*

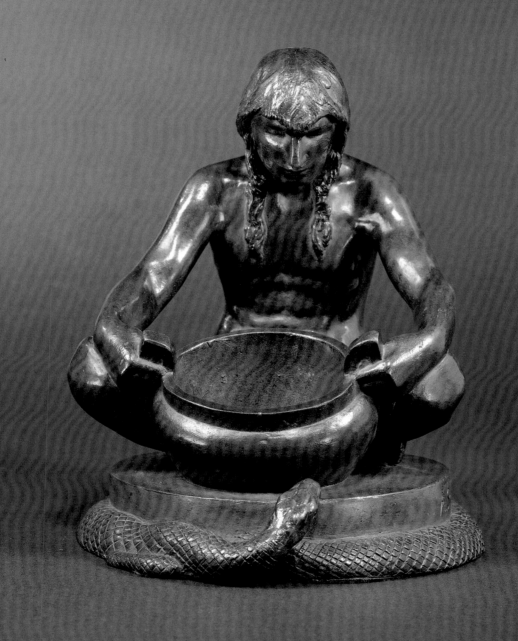

78. **Abastenia St. Leger Eberle** (1878–1942)
Seated Indian, ca. 1910s–20s, bronze, height: 7 inches, signed on the base: *A./ST./L. EBERLE*;
stamped with the foundry mark on the base: *Gorham Co Founders/Q56*

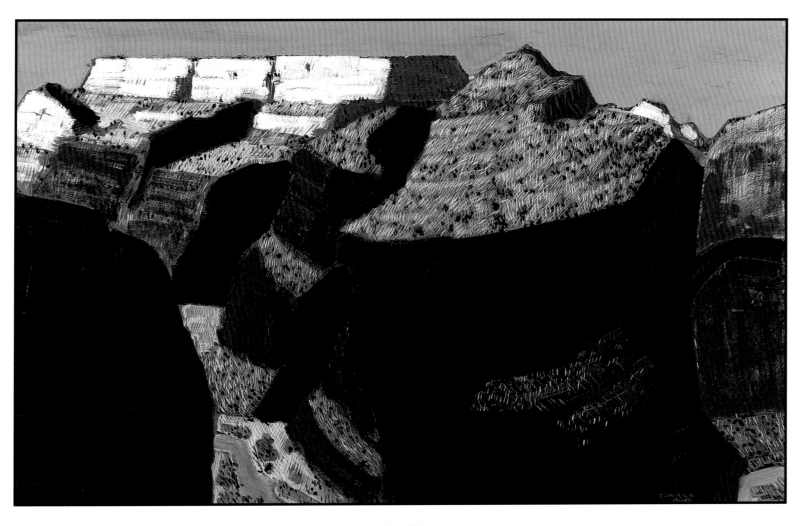

79. Conrad Buff (1886–1975)

Canyon Walls, Zion National Park, Utah, ca. 1920s–30s, oil on masonite, 23½ × 35¼ inches,
signed lower right: *Conrad Buff*

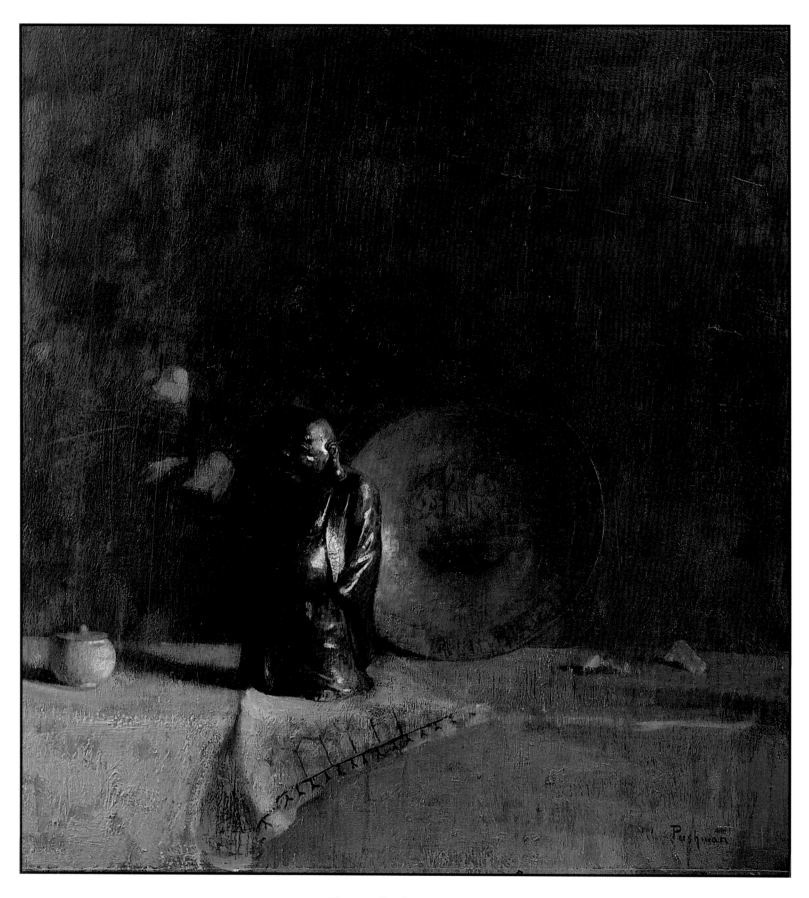

80. **Hovsep Pushman** (1877–1966)
The Green Plate, oil on canvas, 21½ × 19 inches,
signed lower right: *Pushman*

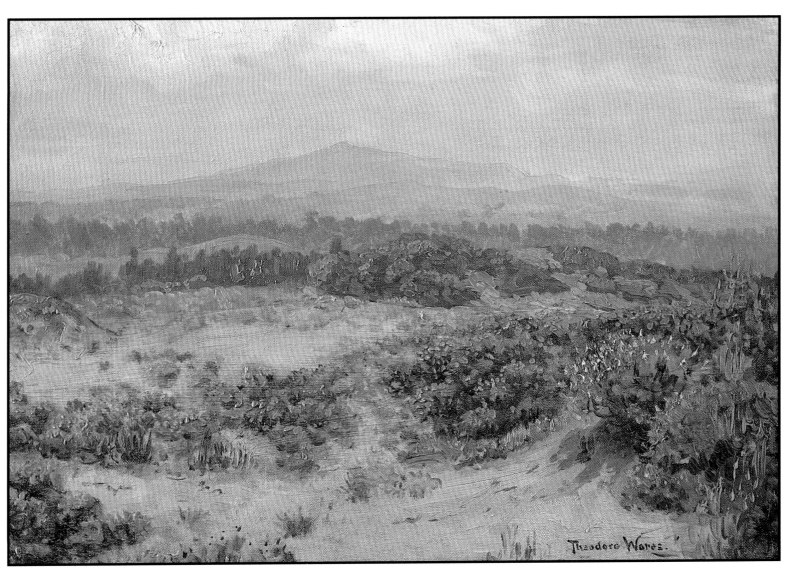

81. **Theodore Wores** (1859–1939)
The Sand Dunes of San Francisco, California, 1905, oil on board, 12 × 16¼ inches,
signed lower right: *Theodore Wores*

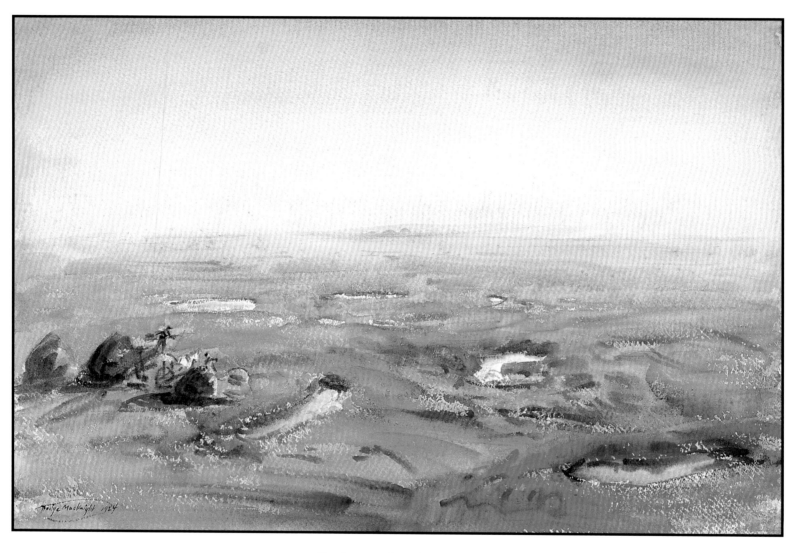

82. **Dodge Macknight** (1860–1950)

Haying in the Salt Marshes, 1924, watercolor on paper, 16 × 23 inches,
signed and dated lower left: *Dodge Macknight 1924*

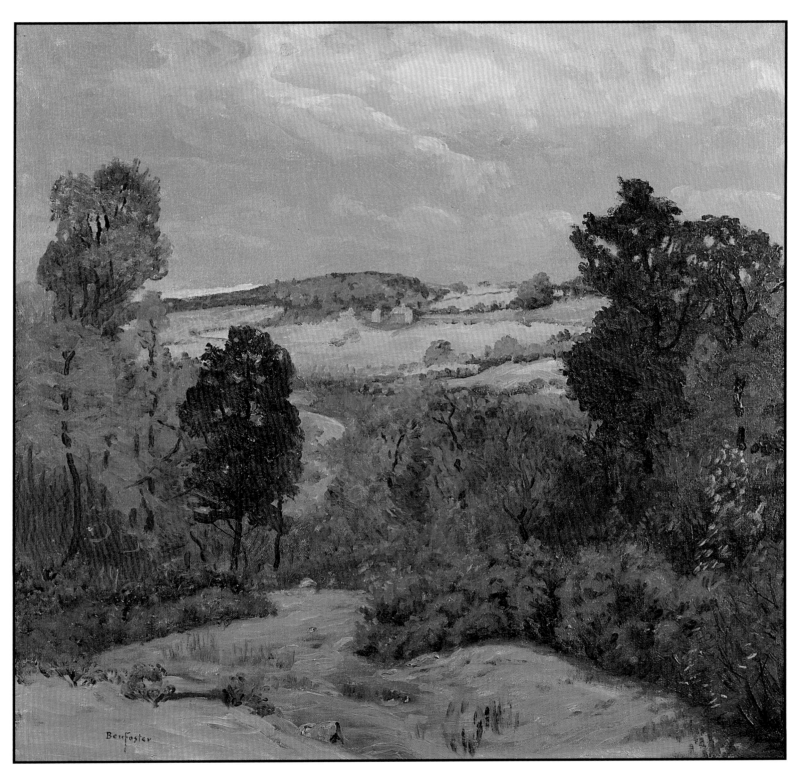

83. **Ben Foster** (1852–1926)
Autumn in New England, ca. 1900, oil on canvas, 24¼ × 24¼ inches,
signed lower left: *Ben Foster*

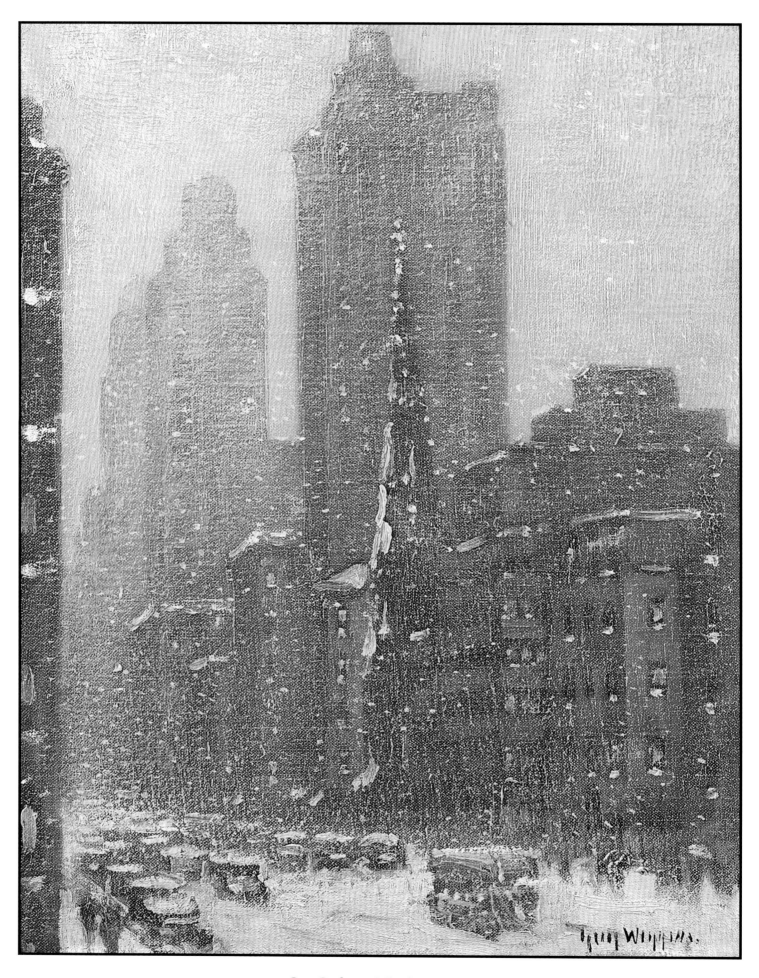

84. **Guy Carleton Wiggins** (1883–1962)

Midtown New York in the Snow, 1935, oil on canvasboard, 16 × 12 inches, signed lower right: *Guy Wiggins*;
also signed, dated, and inscribed verso: *Mid Town, Winter/New York/Guy Wiggins/ 1935*

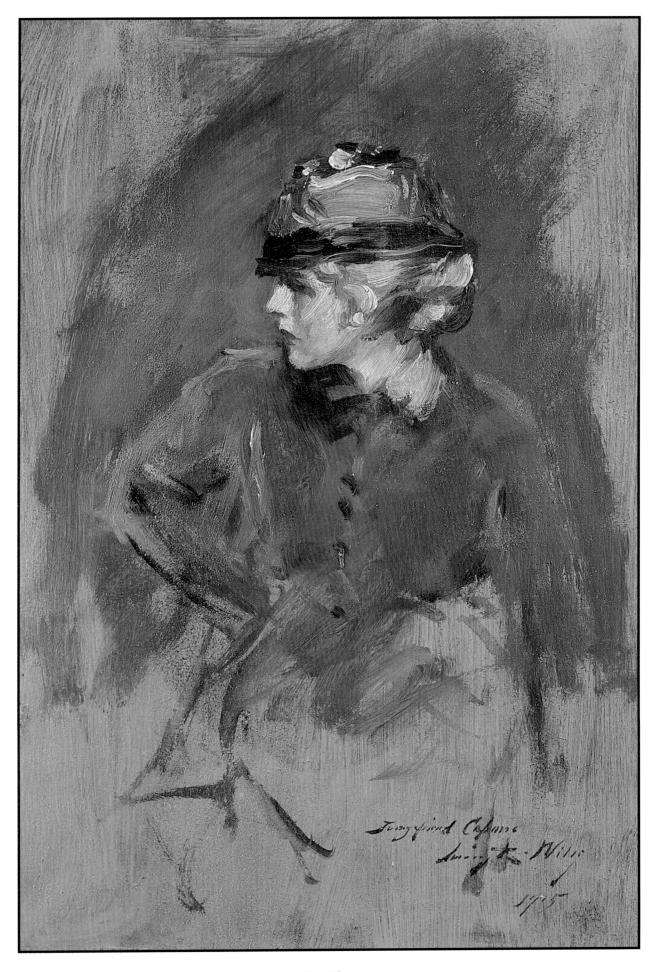

85. Irving R. Wiles (1861–1948)

Woman in Blue, 1915, oil on canvas, 14 × 9 inches,

signed, dated, and dedicated lower right: *To my friend Capone/ Irving Wiles/ 1915*

Cecilia Beaux

(1855–1942)

Born into an affluent family in Philadelphia, Cecilia Beaux was one of only a few women artists of her generation to achieve widespread critical and popular acclaim. As a portraitist, she attracted a notable clientele from the world of politics and fashionable society. However, she was best known for her figure subjects, especially her striking depictions of women and children, whom she portrayed with flair and psychological insight. Her canvases—characterized by innovative compositions, rich colors, and a deft, painterly technique—dazzled the public and attracted the admiration of her fellow artists, including William Merritt Chase, who described her as "not only the greatest living woman painter, but the best that has ever lived."

Beaux received art lessons from various relatives before studying with the Dutch-born painter Adolf Van der Whelen in 1872 or 1873. She continued her training at the Pennsylvania Academy of the Fine Arts from 1877 to 1879 and studied privately with William Sartain from 1881 to 1883. Beaux established a studio in Philadelphia in 1889, and six years later she became the first full-time woman instructor at the Pennsylvania Academy, retaining that position until 1916. Philadelphia remained her home base until about 1900, when she moved to New York. After 1905, she spent summers in Gloucester, Massachusetts, where she died in 1942. Her autobiography, *Background with Figures,* was published in 1930.

Ben Benn

(1884–1983)

Ben Benn, an American exponent of Fauvism, was born Benjamin Rosenberg in Poland in 1884. He received his formal training in New York, studying at the National Academy of Design from 1904 until 1908. His developing aesthetic was inspired by the vanguard European painting he saw at the Armory Show of 1913, especially works by Paul Cézanne, the Cubists, and Henri Matisse. Two years later he saw an El Greco exhibition at New York's Knoedler Gallery and was greatly influenced by the Spanish Baroque master's expressive distortion of form and vigorous technique. Benn assimilated these varied sources into his own style, characterized by flat, simplified forms, a limited palette of bold colors, and a Cézannesque approach to compositional design that he applied to figure subjects, landscapes, and still lifes. Over the years he often modified his approach, darkening his palette during the 1930s and experimenting with abstraction in the forties and with expressive realism in the fifties. As noted by the critic Sidney Geist, Benn saw painting as a "physical act, a performance, a realm of wit and daring—but always in the service of a subject, and he would speak tenderly of the vase of flowers, the woman, or landscape that impelled him to pick up his brushes." During the mid-1930s, Benn began spending summers in Woodstock, New York, where he became a respected member of the local artists' colony. Since his death in 1983, Benn's paintings have been featured in many exhibitions devoted to American modernism.

Frank W. Benson

(1862–1951)

A leading figure in the Boston School of painting, Frank W. Benson won acclaim in the early twentieth century for his images of women and children, shown outdoors in the sunlight or inside in elegant, discreetly lit interiors. He was born in Salem, Massachusetts, and

received his art training at the School of the Museum of Fine Arts, Boston, and in Paris at the Académie Julian. Benson returned from Europe in 1885, and three years later moved to Boston, where he became an instructor at the School of the Museum of Fine Arts. Along with his close friend and fellow teacher Edmund C. Tarbell, Benson helped to establish the school as one of the outstanding art instruction facilities in the United States. In 1898 Benson joined a number of artists from New York and Boston to form the Ten American Painters, a group dedicated to participating in small exhibitions of high-quality work. Beginning in 1901, Benson spent summers on North Haven Island, Maine, located in Penobscot Bay. There he painted vivid Impressionist images featuring the island's open sunlit hills and his wife and children, clad in white, on hillsides and at the water's edge. In his studio during the winter, Benson maintained a more traditional approach, depicting quiet interiors inhabited by carefully wrought figures in works that evoke the art of the Dutch Little Masters, Jan Vermeer in particular. Always a passionate naturalist and outdoorsman, in the 1920s, Benson focused on wildlife, sporting, and hunting scenes. His depictions of these subjects in oil, watercolor, pen and ink, and etching were extremely popular.

Albert Bierstadt

(1830–1902)

Albert Bierstadt was one of America's preeminent nineteenth-century landscape artists. His paintings of the American West, executed in a tight, naturalistic style with an emphasis on dramatic lighting and pictorial scale, celebrated the inherent beauty and majesty of the Western landscape. Although he was born in Solingen, Germany, Bierstadt grew up in New Bedford, Massachusetts. By 1853 he was in Düsseldorf, where he discovered the work of Carl Friedrich Lessing and Andreas Aachenbach, two painters widely admired for their heroic, highly finished landscape compositions. In 1859 Bierstadt joined Colonel Frederick W. Lander's Overland Trail expedition, a decisive event in his career. The large-scale, panoramic landscapes that he later completed from his sketches and stereoscopic photographs proved immensely popular and established him as the foremost painter of the American frontier. In 1860 the members of the National Academy of Design elected him a full academician. After several painting trips to New Hampshire's White Mountains and to the southern United States, Bierstadt made a second journey west in 1863, resulting in works such as his monumental *The Rocky Mountains, Lander's Peak* (1863; Metropolitan Museum of Art, New York). Over the next two decades the artist visited Europe, the Bahamas, Alaska, and British Columbia, producing paintings that were conspicuous for their naturalistic detail and dramatic, almost sublime, lighting effects. Although Bierstadt's popularity declined during the latter part of the century, he continued to paint until his death in 1902.

Thomas Birch

(1779–1851)

Thomas Birch was one of America's first and finest marine painters as well as one of his era's leading landscape painters. Born in London, Birch was less indebted to English marine painting than to contemporaries such as the landscape painter Joshua Shaw, who also immigrated to the United States. Birch established an important legacy that was continued by American painters of the sea—James Hamilton, Thomas and Edward Moran, Franklin

Briscoe, and William Trost Richards—as well as by Hudson River School artists such as Thomas Cole. Birch received his first training from his father, William Russell Birch, an engraver and painter of enameled miniatures. The Birch family immigrated to the United States in 1794 and settled in Philadelphia. There Thomas assisted his father in preparing *Views of Philadelphia*, images of the city that were engraved in 1788 and 1800 by the firm of W. Birch and Son. However, after these works were completed, Thomas broke away from engraved views to become a portrait painter. He soon turned to painting landscapes and seascapes, expressing his love of nature in topographically accurate and occasionally romanticized scenes of harbors and rural countrysides. His views of harbors and ships at sea, which reflect the influence of seventeenth-century Dutch marine painting, were received with widespread acclaim.

Alfred Thompson Bricher

(1837–1908)

Alfred Thompson Bricher is best known for views of deserted shorelines edged with dramatic rocky outcroppings and views of tranquil seas. He was born in Portsmouth, New Hampshire, and spent his youth in Newburyport, Massachusetts. By the late 1850s he was living in Boston and painting landscapes in the manner of the Hudson River School. In the following decade he focused on marine subjects, working at Mt. Desert Island in Maine and in Northampton, Massachusetts. He also began to use watercolor, a medium in which he created many of his finest works. After moving to New York in 1868, he remained dedicated to capturing quiet, light-filled scenes of coastal areas. His precise rendering of forms reflected his adherence to the Luminist aesthetic. In the 1880s, however, Bricher adopted a more tonal approach; where his colors had always been predominantly pale blues and greens with touches of intense yellow—all harmoniously blended to convey the sensation of a bright, sunny day— he now emphasized a single, dominant color to record atmospheric conditions. After 1881 Bricher spent summers in Southampton, Long Island, where he created a number of views of the expansive coastline and the village. He traveled extensively, too, visiting the coasts of Maine, Massachusetts, Rhode Island, New York, and Canada.

John George Brown

(1831–1913)

John George Brown was the most celebrated painter of genre scenes in America in the late nineteenth century. His realistic depictions of outdoor life and children—especially the street urchins of New York City—were widely known and extremely popular. Brown was born in Bensham, England, and studied at the government school of design at Newcastle under William Bell Scott, a poet, painter, and friend of the Pre-Raphaelites. Brown later pursued his career as an artist in Edinburgh at the Drawing Academy, where he attended painting classes with Robert Scott Lauder. After moving to the United States in 1853, Brown furthered his studies with the miniature painter Thomas Seir Cummings and established himself in New York's illustrious Tenth Street Studio Building. His paintings of the 1860s— tightly rendered, detailed depictions of anecdotal subjects—show the influence of the Pre-Raphaelites as well as the tradition of English and Scottish genre painters such as Augustus

Mulready and Sir David Wilkie. In Brown's genre portrayals, however, he sought to express "contemporaneous truth, which will be of interest to posterity," and by the 1880s he had turned for subject matter to the young newspaper sellers and bootblacks of United States cities. Collected by wealthy patrons and reproduced extensively, Brown's scenes summed up a new feeling of optimism about urban life. During summers in the rural areas of New York and Vermont, Brown painted local farmers and their families. He also created a number of images of fishermen at Grand Manan Island, New Brunswick, Canada.

Charles Francis Browne
(1859–1920)

Charles Francis Browne, an artist of diverse interests and ample talent, earned a distinguished reputation through painting, teaching, and writing art criticism. He also edited the art magazine *Brush and Pencil*. Born in Natick, Massachusetts, Browne trained extensively, first at the School of the Museum of Fine Arts, Boston, and then with Thomas Eakins at the Pennsylvania Academy of the Fine Arts. In 1887 he visited Paris and spent two years as a pupil in Jean-Léon Gérôme's atelier. When he returned in 1891, a commission to paint a mural for the World's Fair drew him to Chicago, where he ultimately settled. During the years that followed he traveled widely, both in Europe and the American West, producing landscapes and figure paintings. He also found time to teach at the Art Institute of Chicago and to serve as art critic for the *Chicago Sunday Tribune*. Browne's early paintings share a stylistic affinity with Tonalism, although he began to experiment with Impressionism about 1900. Contact with Scotland's Glasgow School in 1904 influenced his late work, as is evidenced by soft colors, generalized forms, and effects of light and atmosphere.

William Blair Bruce
(1859–1906)

A painter of landscapes, marines, and figure subjects, William Blair Bruce was a founding member of the Anglo-American artists' colony in Giverny, France, and the first Canadian painter to adopt Impressionism. Born in Hamilton, Ontario, Bruce studied art locally before going to Paris in 1881, where he continued his training at the Académie Julian and formed friendships with a group of young American art students that included Theodore Robinson and Willard Metcalf. After losing about two hundred paintings in a shipwreck in the Gulf of the St. Lawrence in 1885, he went back to Hamilton, remaining there until early 1887, when he returned to Paris. Along with Robinson, Metcalf, and others, he spent the spring and summer of that year painting *en plein air* in Giverny, where he abandoned his academic style in favor of the bright colors and fluid brushwork of Impressionism. In 1888, Bruce married the Swedish sculptor Caroline Benedicks, after which time he resided in Paris and Grez-sur-Loing and made intermittent trips to Canada, Sweden, and Italy. In 1899, he settled permanently in Visby, on Gotland Island, Sweden, where he died. His home there, "Brucebo," has been preserved and is administered by a foundation established by his wife prior to her death. Bruce's letters, published in 1982 as *William Blair Bruce: Letters Home*, provide important details relative to the founding and early history of the Giverny artists' colony, as well as to artistic activity in Victorian Canada.

Karl Buehr

(1866–1952)

A noted figure and landscape painter who was much admired for his skills as a colorist, Karl Buehr was born in Feverbach, Germany, in 1866. After studying intermittently at the Art Institute of Chicago from 1888 to 1897, and with the painter Frank Duveneck in 1899, he continued his training abroad, attending classes at the Académies Julian and Colarossi in Paris before enrolling at the London Art School in 1903. He returned to Paris in 1908. From 1909 until 1911, Buehr and his wife, the miniature painter Mary Hess Buehr, lived in the artists' colony in Giverny, France. There he began portraying female models—often dressed in nineteenth-century gowns—in the open air, employing the decorative Impressionist style favored by Frederick Frieseke, Richard Miller, and other American figure painters working in Giverny during the early 1900s. Buehr was active in the town of Sainte-Geneviève, near Giverny, about 1912 to 1913, after which time he returned to Chicago. Thereafter, he taught for many years at the Art Institute while spending his summers painting landscapes and interior figure subjects in Wyoming, New York.

Conrad Buff

(1886–1975)

A notable figure in the artistic life of southern California during the first half of the twentieth century, Conrad Buff was active as a lithographer, muralist, and illustrator. He was also an acclaimed landscape painter, recognized for his highly individualistic depictions of mountains. Buff was born in Speicher, Switzerland, and studied at the School of Arts and Crafts in St. Gall and in Munich. He immigrated to the United States in 1905, settling first in Wisconsin and a year later in Los Angeles. Buff soon focused on the mountain scenery that would occupy him for the rest of his career, traveling throughout the Southwest and abroad for subject matter. His vigorous style is characterized by bold, highly structured designs and simplified, clearly articulated forms that reveal what he saw as the underlying geometry of nature.

Theodore Earl Butler

(1861–1936)

An important member of the Impressionist artists' colony in Giverny, France, at the turn of the last century, Theodore Butler was one of only a few American painters to have direct contact with Claude Monet. Butler, a painter of figure subjects and landscapes, developed a distinctive style based on a synthesis of Impressionist and Post-Impressionist precepts. In Paris, his work was championed by dealers such as Ambrose Vollard and Paul Durand-Ruel. Born in Columbus, Ohio, Butler studied at the Art Students League in New York and at the Académies Julian, Colarossi, and the Grande Chaumière in Paris. He visited Giverny in 1888, 1890, and 1891, experimenting with modern strategies of light and color. He became a permanent resident of the village in 1892, when he married Suzanne Hoschedé, Monet's stepdaughter. In the ensuing years, Butler evolved his mature style, adopting a high-keyed palette and expressionistic brushwork that he applied to genre scenes of his wife and

children. In 1900, following Suzanne's death in 1899, Butler married her sister Marthe. He came back to New York in 1913, spending the next eight years executing mural commissions and painting urban scenes before returning permanently to Giverny, where he died.

William Merritt Chase

(1849–1916)

William Merritt Chase was a dominant figure in nineteenth-century American painting and in the American Impressionist movement. Born in Williamsburg, Indiana, a small town near Indianapolis, he studied in New York and Munich. On his return to the United States in 1878, he settled in New York, where he became a leader of a generation of cosmopolitan artists who employed styles influenced by modern European art. He was one of the first and most important teachers at the Art Students League and was a prominent exhibitor at the newly formed Society of American Artists. In the late 1870s and early 1880s, Chase often depicted his ornately decorated studio in New York's famous Tenth Street Studio Building, creating images that summed up the experience of the worldly bachelor artist. After his marriage in 1886 to Alice Gerson, Chase lightened his palette and focused greater attention on American subject matter and domestic themes. In the mid- to late 1880s, he painted a series of sparkling views of leisurely life in Manhattan's Central Park and Brooklyn's Tompkins Park that anticipated his adoption of an Impressionist style in the next decade. From 1891 until 1902, Chase conducted outdoor summer classes in Shinnecock, Long Island, where he painted his wife and growing family and the spare beauty of the coastal dunes. There Chase formulated his own vital Impressionist approach, using the style to capture both the sensuous qualities of his subject matter and to convey the joyful feeling of summer. After closing the school, Chase summered abroad, holding classes for art students in Madrid, Florence, Bruges, Venice, and Haarlem. In 1903, he was elected a member of the Ten American Painters, taking the place left open when John Henry Twachtman died the previous year. In the last decade of his life, Chase received high accolades for his art and was given one-artist shows in nearly every important American city.

Walter Clark

(1848–1917)

Walter Clark was a highly respected landscape painter as well as a sculptor. A native of Brooklyn, Clark initially studied engineering at the Massachusetts Institute of Technology before touring Europe, India, China, and Japan in 1869. He later attended the National Academy of Design in New York and studied drawing with Lemuel Wilmarth and sculpture with J. Scott Hartley. Clark began to favor painting after executing a number of portrait busts and works in terracotta. His early landscapes were Tonalist in spirit and emphasized mood and feeling, a style indebted to George Inness, whose studio was adjacent to Clark's in New York City. In the late 1890s he became increasingly influenced by the American Impressionists, and his friends included painters Edward Potthast, John Henry Twachtman, and Joseph DeCamp. Clark earned a number of important awards, including silver medals at two international expositions and the coveted Inness Gold Medal from the National Academy in 1902. Clark was the father of the painter and artist-biographer Eliot Candee Clark (1883–1980).

Jay Hall Connaway

(1893–1970)

Jay Hall Connaway painted landscape and seascape views of New England noted for their vigorous style and often dramatic subject matter. He was born in Liberty, Indiana. After first attending the John Herron Art Institute in Indianapolis, he developed his style and technique under William Merritt Chase at the Art Students League in New York (1911–13). He later studied in Paris at the Académie Julian and the Ecole des Beaux-Arts. Connaway made a number of painting trips to Brittany and lived for many years on Monhegan Island, Maine, where he founded Connaway's Monhegan School of Art. He settled in Dorset, Vermont, in 1947, where he started another art school. He continued the school in Pawlet from 1953 until 1962, when the school merged with the Southern Vermont Art Center. Connaway continued to teach at the school until 1964. Connaway worked in an Impressionist style, employing a brilliant palette and broad, fluid brushwork. Relying on an intuitive sense of design, he eliminated distracting details and generalized natural forms to achieve a strong decorative effect. His paintings celebrate the power and ruggedness of nature under varying conditions of light and weather and reveal his genuine love of the outdoors.

Paul Cornoyer

(1864–1923)

Born in St. Louis, Paul Cornoyer studied at the St. Louis School of Art while working as a reporter for a local newspaper. In 1889, he went to Paris, where he attended the Académie Julian, exhibited his paintings at the Salon, and visited the art capitals of Europe. During this period he began rendering cityscapes, a theme that occupied him for the rest of his career. He returned to St. Louis in 1894 and remained there until 1898 when he moved to New York at the suggestion of the painter William Merritt Chase. Cornoyer subsequently turned his attention to the city's parks, streets, and squares, which he depicted in sunlight, moonlight, rain, and snow, often intermingling natural and artificial light. He exhibited his work at the national annuals and soon developed a reputation as one of the most significant interpreters of the American urban scene. Cornoyer was a popular teacher, attracting many students to his summer painting classes in Gloucester, Massachusetts. He moved permanently to East Gloucester in 1917 and died there six years later.

Hyman Francis Criss

(1901–1973)

A painter identified with the American Precisionist movement, Hyman Francis Criss was renowned for his colorful, tightly rendered portrayals of the architectonic forms within the urban landscape, especially those of Manhattan. Criss was born in London but grew up in Philadelphia, where he studied at the Pennsylvania Academy of the Fine Arts. He also attended New York's Art Students League while supporting himself by designing screens for decorators. In the 1930s, Criss depicted New York's architecture—notably skyscrapers, subway kiosks, and the elevated subway trains—using a style inspired by the high-keyed, nondescript coloration and flat, two-dimensional planes of Synthetic Cubism. During the later 1930s Criss helped to found An American Group, an organization of socially oriented artists

such as Philip Evergood, William Gropper, and Jack Levine. His art of the time, which focused on humanistic themes and explored subjects related to fascism, was also imbued with Surrealist overtones. He returned to cityscapes in the 1950s, creating images closer to the Neo-Impressionist technique of Pointillism than to the hard-edged approach of his earlier period.

Jasper Francis Cropsey

(1823–1900)

Jasper Francis Cropsey was a major figure in the Hudson River School and one of our finest mid-nineteenth-century landscape painters. He was born in Rossville, on Staten Island, and trained as an architect in the Manhattan office of Joseph Trench. His interest in water-color renderings led him to try his hand at painting, and in 1843, the same year he opened a private architectural practice, he exhibited one of his first paintings at the National Academy of Design. By 1845 he had abandoned architecture to devote his energies entirely to landscape painting. During the 1850s he painted throughout New England, and between 1856 and 1863 he lived in London. When he exhibited *Autumn—On the Hudson River* (1860; National Gallery of Art, Washington, D.C.) at a London gallery, he gained renown on both sides of the Atlantic. In 1867 Cropsey achieved a lifelong ambition when he designed and built Aladdin, a Gothic-style mansion in Warwick, New York, equipped with a spectacular, sky lit painting studio. Here he painted throughout the 1870s, studying his treasured sketch-books and drawing on his memories to fuel his prolific brush. His work from the last fifteen years of his life, much of it in watercolor, reveals Cropsey's enthusiasm for an idealized, optimistic view of the United States as symbolized by its landscape.

Arthur B. Davies

(1862–1928)

Recognized for his distinctive and highly personal mode of artistic expression, Arthur B. Davies played a vital role in the development of American modernism. A figure painter, he was renowned for his Symbolist-inspired renderings of female figures in ideal Arcadian landscapes, which carried on the tradition of American visionary painting established by such artists as Albert Pinkham Ryder and Ralph Blakelock. Davies exhibited his work with the group of artists known as the Eight, held at the Macbeth Gallery in New York in 1908. He was later instrumental in organizing the 1913 Armory Show, a watershed event in the history of American art. Despite his enthusiastic support of the avant-garde, Davies eschewed Cubist fragmentation and the vivid coloration of Fauvism in favor of a realist style influenced by European Symbolism, German romanticism, and his own inner vision of nature. Throughout his career, Davies produced oils and pastels, crayon and pencil drawings, as well as lithographs, drypoints, and sculptures. Toward the end of his life, he executed many watercolors, taking advantage of the medium's fluidity, transparency, and easy portability.

Mauritz Frederick Hendrik de Haas

(1832–1895)

Mauritz Frederick Hendrik de Haas was a marine painter renowned for his dramatic and romantic moonlit scenes as well as for disseminating knowledge of Dutch marine painting

in America. He was born in Rotterdam and studied there at the Academy of Fine Arts, as well as in The Hague with the marine painter Louis Meiger. De Haas was honored in his native country; he was the official artist of the Dutch navy and his works were purchased by Queen Sophia of the Netherlands and shown at the Royal Academy in The Hague. Despite this recognition, he chose to immigrate to the United States in 1859. He settled in New York and established himself as an etcher, watercolorist, and painter in oil, focusing on coastal and maritime subjects. He soon took an active role in the New York art scene. In 1867, he became an academician of the National Academy of Design and a member of the American Watercolor Society. He later exhibited at the Brooklyn Art Association, the Boston Athenaeum, and the Pennsylvania Academy of the Fine Arts. De Haas's work was admired broadly during his era. In the catalogue for his memorial sale in 1896, a critic commended his art for "its animation, its qualities of color, its sentiment, and its truth." De Haas's brother William Frederick (1830–1880) and his son Maurice (d. 1897), were also marine painters.

Paul de Longpré

(1855–1911)

A talented *fleuriste,* Paul de Longpré began his career in his native France, where he painted flower decorations on fans. Although he is said to have studied briefly under Léon Bonnat and Jean-Léon Gérôme while in Paris, he was basically a self-taught artist who drew inspiration directly from nature. He began exhibiting watercolors of flowers at the Paris Salon in 1876 and did so intermittently until 1890, when he lost his savings in a bank failure and immigrated to New York. De Longpré worked in relative obscurity until 1895, when, on the occasion of a major exhibition of his work at New York's American Art Galleries, he was hailed in *Art Interchange* as "America's foremost flower painter." Two years later, a writer for the *New York Times* lauded his ability to combine mood and poetic effect with "the knowledge of a botanist and a marvelous fidelity in the reproduction of both form and color." De Longpré became so successful that in 1898 he settled in California and built a lavish, Moorish-Mission-style villa in Hollywood. There he cultivated a three-acre flower garden that provided him with the fresh specimens he so loved to paint. De Longpré depicted a variety of blossoms, favoring simple, harmonious arrangements shown against unadorned backgrounds. His firm draftsmanship, sensitive colorism, and awareness of the symbolic language of flowers contributed to his immense popularity at the turn of the last century.

Raoul de Longpré

(b. 1843)

Raoul de Longpré came from a family of *fleuristes* associated with Lyons, France, an important center of flower painting during the nineteenth century. His father, Jean-Antoine, was a decorator of fans who exhibited floral still lifes in both Paris and Lyons, while his brother, Paul, was a professional flower painter, first in Paris and later in the United States. In contrast to Paul, who painted a wide range of flowers, Raoul was drawn to informal arrangements of lilacs and roses—depicted individually or together—which he portrayed in one of three ways: arranged on a stone ledge or plinth, newly cut and strewn on a floor or other surface, or as a bouquet floating mysteriously in the air. Like other flower painters of the nineteenth century, his choice of motifs was likely inspired by the language-of-flowers literature available

in France and elsewhere in Europe. Working in watercolor or gouache, he combined surety of touch with a poetic and wistful interpretation of his subject. Although he never lived in America, his work found its way into many public and private collections in the United States, possibly through the efforts of Paul, who might have acted as his agent.

Arthur Wesley Dow
(1857–1922)

Arthur Wesley Dow was an artist, a teacher, and a leader of the American Arts and Crafts movement at the turn of the twentieth century. Most significantly, he developed a new philosophical approach to art that synthesized Eastern and Western aesthetics. His own works exemplified his brand of Synthetism and were far ahead of their time, while his ideas influenced the modernist artists of the next generation, including his students Max Weber and Georgia O'Keeffe. Dow was born in Ipswich, Massachusetts, and studied in Worcester and Boston before continuing his training in Paris in 1884. After he returned to America from Europe in 1887, he became interested in Egyptian and Aztec artifacts, which he saw in Boston at the Public Library and at the Museum of Fine Arts. He also studied the prints of the Japanese artist Hokusai and began making woodcuts of Boston's North Shore that were inspired by the Japanese reverence for nature. In 1893 Dow was appointed assistant curator of the Japanese collection at the Museum of Fine Arts, and in 1899 he published his book *Composition*, which disseminated his ideas to art students in the public schools. Dow later wrote additional books on design including *Theory and Practice of Teaching Art* (1908) and *Constructive Art Teaching* (1913). Dow's active teaching career included posts at the Pratt Institute, the Art Students League, and Columbia University's Teachers College. After 1900 Dow maintained a studio in his native Ipswich and conducted summer classes there. The nearby marshes and the area of Bayberry Hill were frequent subjects of his landscapes. Prints took up most of his time during the first decade of the century, but he returned to oils in 1907, experimenting with a brighter palette and more expressive brushwork. His trips to the Grand Canyon in 1911 and 1912 resulted in original works filled with vivid color harmonies. In the last phase of his career, Dow painted often at Gay Head, on Martha's Vineyard, and visited the West Coast, painting in Oregon and California.

Charles Harry Eaton
(1850–1901)

Charles Harry Eaton was a prominent late-nineteenth-century artist known for landscapes as well as portraits and still lifes. Largely self-taught, Eaton developed a descriptive, naturalistic style that combined subtle lighting with vivid atmospheric effects in order to capture the various moods of nature. Eaton was born in Akron, Ohio, and moved to New York about 1881. He was active in a number of artist clubs and associations and exhibited his work frequently in Chicago, Boston, Philadelphia, and New York. In 1887 his *Lily Pond* was purchased by the Detroit Museum. Six years later the National Academy of Design elected him a member. Working in both oil and watercolor, Eaton won a number of important awards and prizes, including the prestigious Evans Prize at the American Watercolor Society in 1898.

Charles Warren Eaton

(1857–1937)

A major figure in the American Tonalist movement, Charles Warren Eaton was guided by his desire to convey his subjective responses to nature. He eschewed grandiose vistas in favor of quiet, more intimate views, which he depicted at dawn or dusk. Born in Albany, Eaton trained in New York at the National Academy of Design and the Art Students League. A trip to Europe in 1886 provided him with the opportunity to study contemporary art. However, the most important influence on his aesthetic was George Inness, a painter of poetic landscapes in the Barbizon mode, whom he met in 1889. Eaton established a summer residence in Bloomfield, New Jersey, in 1887 and spent the next decade depicting the local countryside during the late autumn and winter. After 1900, he made seasonal visits to the Connecticut towns of Thompson and Colebrook, where he developed his signature theme—a grove of pine trees silhouetted against sunset or moonlit skies. Eaton also painted actively in Belgium, Italy, and Glacier Park, Montana.

Abastenia St. Leger Eberle

(1878–1942)

An important American sculptor of the early twentieth century, Abastenia St. Leger Eberle is remembered today for her social realist art, especially her sensitive and sympathetic portrayals of the urban poor. Active in feminist causes and a follower of the social reformist Jane Addams, Eberle helped organize an exhibition of women artists to raise money for the suffrage movement in 1915. A native of Webster City, Iowa, Eberle was raised in Canton, Ohio, and moved with her family when she was twenty to Puerto Rico. In 1899, she settled in New York, where she enrolled at the Art Students League, studying there until 1902 with Kenyon Cox and the sculptor George Gray Barnard. She paid her way through school with prizes and scholarships. In 1908, she established a home and studio on New York's Lower East Side, where she and the prominent animal sculptor Anna Vaughn Hyatt shared an apartment and collaborated on some sculptures in which Hyatt created the animals and Eberle the human figures. In her own bronzes, Eberle focused on immigrant women and street children; these works garnered her significant critical attention; her realist style was often compared with that of the Ashcan painters. Eberle had her first one-artist exhibition in 1907 at New York's Macbeth Galleries. She exhibited regularly at the National Academy of Design in New York and at the Pennsylvania Academy of the Fine Arts in Philadelphia, and she was the recipient of several important awards.

Ben Foster

(1852–1926)

A talented painter associated with the artistic life of New York and Connecticut, Ben Foster was born in North Anson, Maine, in 1852. He moved to New York at the age of eighteen and spent twelve years in the commercial world before enrolling at the Art Students League about 1882. He studied privately with the painter Abbott Handerson Thayer, and in 1886 he went to Paris to continue his training under Amié Merot, Luc Olivier Merson, and Harry Thompson. Returning to America, he thenceforth divided his time between New York and

his farm in Cornwall Hollow, Connecticut, where he painted pure landscapes as well as depictions of meadows with flocks of sheep. He often portrayed the New England country-side in the quiet light of dawn and dusk or under moonlit skies—favoring the subdued palette and fluid brushwork associated with Tonalism. Foster's paintings won many awards and prizes, both in the United States and abroad, and prompted comparisons with the art of the French painter Jean Charles Cazin. In addition to his activity as an artist, Foster wrote concise and perceptive art criticism for the *New York Evening Post* and was an occasional contributor to the *Nation*.

Frederick Frieseke
(1874–1939)

The leading American Impressionist working in Giverny, France, during the early 1900s, Frederick Frieseke won international acclaim for his colorful, light-filled portrayals of the female figure. His signature style—which served as the dominant aesthetic in Giverny for well over a decade—was based on the synthesis of Impressionist light, color, and subject matter with the decorative aspects of Post-Impressionism. Frieseke was born in Owosso, Michigan. After studying at the Art Institute of Chicago and the Art Students League of New York, he went to Paris in 1898, resuming his training at the Académies Julian and Carmen, where he was taught by James Abbott McNeill Whistler. During the early 1900s he depicted women in sparsely furnished interiors, working in a Tonalist style reminiscent of Whistler's. In 1906 he took a house in Giverny, not far from where Claude Monet lived. There Frieseke combined the bright palette and loose brushwork of Impressionism with the rich pattern-ing favored by Nabis painters such as Edouard Vuillard and Pierre Bonnard. His portrayals of women in intimate domestic settings and in sunlit flower gardens won him acclaim, both in Europe and the United States, and inspired other members of the American Givernois, among them Richard Miller, Karl Anderson, and Louis Ritman. In 1919, Frieseke moved to Le Mesnil-sur-Blangy, where he remained until his death. During his later years he continued to paint the female figure and produced many portraits, imbuing his work with a greater sense of realism.

Daniel Garber
(1880–1958)

A leading figure in the New Hope School of American Impressionism, Daniel Garber is best known for landscapes combining an Impressionist investigation of light with a refined decorative approach in which natural forms are delicately interwoven into tapestry-like compositions. Born in North Manchester, Indiana, Garber studied at the Cincinnati Art Academy, the Darby Summer School in Fort Washington, Pennsylvania, and the Pennsylvania Academy of the Fine Arts, where he was a popular teacher from 1909 to 1950. He began his career as an illustrator, commercial artist, and portrait painter. On a visit to Europe between 1904 and 1907, he developed his mature style, which reflects the influence of the art of the Italian Divisionist Giovanni Segantini. After his return to the United States, Garber settled in the Bucks County, Pennsylvania, town of Lumberville—north of New Hope, where he moved into a home he called "Cuttaloosa." In Bucks County, he became close to the other Impressionist painters in the area—including Edward Redfield, William Langson Lathrop,

Walter Schofield, Charles Rosen, Henry Bayley Snell, and Robert Spencer—who together became known as the New Hope School. Garber's works, notable for their meticulous and delicate draftsmanship, stood in contrast to the aggressively painted images by some of his fellow New Hope painters. In his landscapes, most of which are based on scenes of the countryside of Pennsylvania and New Jersey, he conjured a paradisiacal world based on reality but given a surreal perfection. Garber was also a talented portrait painter, who created portraits on commission in addition to images of his family and friends.

Edward Gay

(1837–1928)

Edward Gay was born near Mullingar, County Westmeath, Ireland, but grew up in Albany, New York. He began drawing as a youth and later made sketching trips to Lake George with the painter James M. Hart. In 1862 he traveled to Karlsruhe, Germany, spending two years studying at the local art academy. He lived in New York City from 1868 to 1870, after which time he settled in Mount Vernon, New York. Gay painted views of the local countryside as well as scenery in Long Island and Connecticut, working in the detailed, transcriptive manner of the Hudson River School. However, after seeing the atmospheric canvases of J. M. W. Turner and the French Barbizon School on a trip to Europe in 1881, he returned to America and began to employ a broad, more painterly style that allowed him to convey aspects of light and atmosphere. Gay's new aesthetic direction was highly successful; sales of his oils were brisk, especially when he joined the prestigious Macbeth Galleries in New York. The influential critic Sadakichi Hartmann declared him one of only a few "old-school landscapists" to master this new, more progressive mode of landscape painting. After 1900, Gay spent many winters in Florida. In 1905, he built a vacation house at Cragsmoor, a well-known artists' colony in upstate New York.

Arthur Clifton Goodwin

(1866–1929)

A native of Portsmouth, New Hampshire, Goodwin was a relative latecomer to art when he began to paint about 1900. He was largely self-taught but closely studied the works of the American Impressionists and Ashcan painters. Working primarily in oil and pastel, he developed an Impressionist style characterized by vigorous, sketchy brushwork and a vibrant, high-keyed palette. Over the next few years his lively, colorful renderings of Boston's parks, docks, and plazas attracted a steady clientele. In 1921 he moved to New York City and rented a studio on Washington Square. Goodwin was one of the few American Impressionists who preferred urban subjects, and his views of New York's avenues, bridges, and parks are memorable for their imaginative design and glowing light. The artist and his wife later moved to a farm in Chatham, New York, an area that inspired him to paint many picturesque landscape views.

Aaron Harry Gorson

(1872–1933)

Aaron Harry Gorson was a pioneering painter of the American industrial landscape. Unlike the later Precisionists, who focused on the abstract forms of industry, Gorson celebrated

the sheer spectacle and physical beauty that he discovered in this subject. He was born in Kovno (Kaunas) in Lithuania and came to America in 1888, joining his brother in Philadelphia. There he worked as a machine operator in a clothing factory while taking night classes in art, first at the Spring Garden Institute and later at the Pennsylvania Academy of the Fine Arts, where he studied with Thomas Anshutz, whose realist style he quickly absorbed. Gorson traveled to Paris about 1900 and attended the Académies Julian and Colarossi, studying under Jean Paul Laurens and Benjamin Constant. He became intrigued by James Abbott McNeill Whistler's art, which inspired many of his later landscape scenes of twilight, early morning, night, and foggy days that he frequently titled *Nocturne* or *Prelude*. Returning to Philadelphia in 1902, Gorson was soon drawn to Pittsburgh by lucrative portrait commissions, but Pittsburgh's industrial steel mills ultimately proved his preferred subject. Working in a realist mode with subtle Impressionist inflections, Gorson spent the next eighteen years painting these sprawling mills, often depicting them in night scenes that emphasized dramatic lighting and atmospheric effects. In 1921 the artist moved to New York, where he lived and painted until his death.

Emile Gruppe

(1896–1978)

An important figure in the artistic community of Cape Ann, Massachusetts, Emile Gruppe garnered acclaim for his vigorously rendered depictions of the waterfronts of Gloucester and Rockport. Born in Rochester, New York, he was the son of the landscape and marine painter Charles P. Gruppe (1860-1940), who gave him his earliest art lessons. He received his formal training in New York at the National Academy of Design and the Art Students League and in Paris at the Grande Chaumière. He later received instruction from John F. Carlson in Woodstock, New York, and Charles W. Hawthorne in Provincetown, Massachusetts, evolving a style in which he combined Impressionist strategies of light and color with a realistic portrayal of nature. He made his first visit to Gloucester in 1925, and four years later he began conducting outdoor painting classes there. He went on to open the Gruppe Summer School in Gloucester in 1942, which he operated until his death.

John Haberle

(1856–1933)

John Haberle is recognized today as one of the foremost trompe l'oeil painters of the late nineteenth century. His still lifes are renowned for their remarkable technical accomplishment, droll humor, and originality. Born in New Haven, Connecticut, Haberle trained initially as a lithographer's apprentice but found time to draw and paint. In 1883 he helped establish the New Haven Sketch Club, in which he was an active member and drawing instructor. He later studied briefly at New York's National Academy of Design, where in 1887 he exhibited a still life of money—*Imitation* (location unknown)—which was subsequently purchased by the prominent American art collector Thomas B. Clarke. Haberle's patronage increased steadily and included many saloon and hotel keepers, who were attracted to his pictures for their wit and satire. Regrettably, his career as a trompe l'oeil painter was short-lived. After completing *A Bachelor's Drawer* in 1894 (Metropolitan Museum of Art, New York),

Haberle abandoned his meticulous technique because of failing eyesight. He later painted Impressionist still lifes and worked as a decorator, muralist, and sculptor.

Childe Hassam
(1859–1935)

A preeminent American Impressionist, Childe Hassam painted a broad range of subjects, including landscapes of New England and Long Island, interior genre subjects, and still lifes. He was also the finest American Impressionist to focus on the urban scene, and his images of New York in all seasons encapsulate the beauty and vitality of the emerging metropolis. Hassam was born in Dorchester, Massachusetts, the descendant of sea captains and Revolutionary War patriots. He began his career as a wood engraver and illustrator and developed his skills as a painter through studies at the Boston Art Club (1877–78) and through private training with William Rimmer and Ignaz M. Gaugengigl. Hassam made his first trip to Europe in 1883, visiting England, France, Spain, Italy, and the Netherlands. Returning to Boston, he painted the city's streets and parks, often depicting them under rainy or overcast skies. He resided in Paris from 1886 to 1889, attending classes at the Académie Julian and assimilating Impressionist tenets. He returned to the United States in the fall of 1889 and settled in New York City, where he began to depict the urban scene with vibrant color and shimmering brushwork. He also painted landscapes, and from 1890 through 1920 one of his favorite summer painting locales was Appledore, one of the small islands off the New Hampshire coast. As a patriotic gesture, during World War I, Hassam created his famed "flag day" paintings, featuring the American flags that hung from the tall buildings along New York's Fifth Avenue. In 1904, 1908, and 1914, he made trips to the American West, painting in California and Oregon, where he was deeply inspired by the clear blue skies and rolling landscape. After 1915 he became involved in printmaking, becoming an accomplished practitioner, especially in etching. Four years later, he moved permanently to East Hampton, Long Island. Many of his later works in oil were characterized by his new willingness to experiment with pure color, simplified compositions, and elongated brushwork, reflecting his awareness of Post-Impressionist design principles.

Thomas H. Hope
(1832–1926)

Both a musician and a painter, Thomas H. Hope is remembered today primarily for his trompe l'oeil still-life paintings. He was originally from England but immigrated to the United States in the early 1860s, enlisting in the 17th Connecticut Volunteers and serving as a musician during the Civil War. He and his family later settled in Philadelphia, where Hope attended the Pennsylvania Academy of the Fine Arts. He played the cornet professionally and is thought to have worked as a bandmaster. Hope's artistic style tends toward a tightly painted, highly finished trompe l'oeil realism that suggests the influence of William Harnett and John Frederick Peto, artists who worked and exhibited in Philadelphia when Hope was studying there. In addition to his still-life paintings, Hope also produced landscapes, genre scenes, and portraits. By 1886 the artist and his family had moved to Connecticut, where he resided until his death.

William Morris Hunt

(1824–1879)

William Morris Hunt challenged and transformed artistic tastes not only in Boston, where he was based, but throughout the country. He was one of the first Americans to be influenced by the French Barbizon School, and as a result of this exposure, he led artists to reject the literal landscapes of Thomas Cole, Frederic Church, and Asher B. Durand, in favor of a poetic and subjective mode of expression. He brought artists and patrons into extensive contact with European painting, and through his teaching and writing he disseminated his ideas to a wide audience. Hunt's presence in the American art scene was further enhanced by his close relationship with his brother Richard Morris, the most prominent American architect of the era. Born in Brattleboro, Vermont, Hunt was a member of New England's social elite. He studied art at Harvard (until he was suspended from the school); in Rome with sculptor Henry Kirke Brown (1844); at the Düsseldorf Academy (1845); and in Paris with Thomas Couture (1842–52), who influenced Hunt's adoption of a painterly technique and a new approach to form that emphasized the artist's impression over a traditional academic method. Another formative influence was the work of the French Barbizon painter Jean-François Millet. While painting with Millet, Hunt developed a plein-air technique and became interested in rural subject matter. After returning to Boston in 1855, he was active as a portraitist and landscape painter and influenced a generation of young artists, who also trained in his studio. In 1872 most of his life's work, as well as his collection of French paintings, was lost in a fire that destroyed much of central Boston. Temporarily unable to work, Hunt made a brief trip to northeastern Florida, visiting Magnolia Springs and Saint Augustine. When he settled once again in Boston, he concentrated more intensively on landscape themes, working in the city and its environs. Hunt continued in this direction, taking his aesthetic cue from both Couture and Millet, until 1878, when he received a commission to paint two murals for the New York State Capitol at Albany. In September 1879 he drowned while vacationing on the Isles of Shoals in New Hampshire.

George Inness

(1825–1894)

One of the most prominent figures in nineteenth-century American art, George Inness took a poetic and highly expressive approach to landscape painting. Born in Newburgh, New York, he studied with Regis Gignoux in New York City about 1843. His earliest landscapes were painted in the detailed manner of the Hudson River School. He traveled to Italy from 1851 to 1852 and to France from 1853 to 1854, where he was deeply impressed by the broadly painted rural landscapes of the French Barbizon School. So inspired, he changed his style, using rich colors and fluent brushwork to create mood and feeling. He also abandoned wilderness scenery and instead focused on the civilized landscape. In 1864, Inness moved to Eagleswood, near Perth Amboy, New Jersey. After periods of activity in Europe, Boston, and New York during the early-to-mid-1870s, he settled in Montclair, New Jersey, in 1878. In the ensuing years, he painted more dramatic subjects and explored the emotive possibilities of color. A spiritualist influenced by the teachings of the eighteenth-century religious thinker Emanuel Swedenborg, Inness sought to reconcile the real with the

ideal, and in so doing, he produced some of his most imaginative canvases. These lyrical paintings of the 1890s—often woodland interiors at dawn or dusk—set the example for Henry Ward Ranger, Charles Warren Eaton, and other American Tonalists. As well as painting in New York, New Jersey and Connecticut, Inness was also active in California and Florida.

Charles Salis Kaelin
(1858–1929)

Described as an artist whose "love of nature amounted to a passion," Charles Salis Kaelin was a respected member of the artists' colony at Rockport, Massachusetts, during the early twentieth century. The son of a Swiss lithographer, he initiated his formal training in his hometown of Cincinnati, studying at the McMicken School of Design and privately under the Impressionist painter John Henry Twachtman. Moving to New York in 1879, he continued his studies at the Art Students League and then worked as a lithographer. Back in Cincinnati in 1892, he joined the prestigious Strobridge Lithography Company as a designer of theater posters and calendars and spent his free time on sketching trips to southern Ohio and Kentucky, where he created delicate pastel landscapes in the poetic manner of Twachtman. Kaelin first visited Gloucester, Massachusetts, on the Cape Ann peninsula, in 1900 and continued to make seasonal trips there until settling permanently in the nearby town of Rockport in 1916. It was about this time that he evolved an advanced Divisionist technique—rooted in European Post-Impressionism—wherein emphatic strokes of crayon or oil paint are tightly woven together to create an intricate tapestry of line and color. He applied this method, deemed "daring" and "experimental" by contemporary critics, to his many depictions of the harbors, coastlines, and woodlands of Cape Ann.

Max Kalish
(1891–1945)

Max Kalish was a realist sculptor who specialized in portraying laborers. Working mostly in bronze, Kalish blended classical and modern European sculptural styles to produce works that he considered to be characteristically American. He remarked in 1926, "I learned that the American workman is a distinct type. . . . I saw him upstanding, independent, proud to do hard work." Kalish was born in Valozin, Lithuania, and immigrated with his family to Cleveland in 1898. He studied at the Cleveland School of Art, the National Academy of Design in New York, and privately with Alexander Stirling Calder, Cartaino di Sciarrino Pietro, and Isidore Konti. From 1912 to 1913, Kalish trained in Paris at the Académie Colarossi and the Ecole des Beaux-Arts. After serving during World War I, Kalish returned to Paris, where he spent six months of the year for the next twelve years. He began to focus on the subject of the American laborer in 1921, creating sculptures of lively and vigorous workers that celebrated their fortitude and diligence. After 1932, Kalish began to spend less time in Paris, instead dividing his time between Cleveland and New York. In 1942, he produced a series of portrait statuettes of prominent contemporary Americans, a project that was left uncompleted when he died of cancer at fifty-four.

Otis Kaye

(1885–1974)

Best known for his images of American currency, Otis Kaye continued the trompe l'oeil tradition of William Harnett, John Haberle, and John Frederick Peto well into the twentieth century. A master of visual illusion, Kaye was known for his technical virtuosity and his highly inventive compositions. He was fond of the visual pun: many of Kaye's money pictures from the 1920s and 1930s include humorous references to the economic and social eccentricities of the era as well as to the paintings by trompe l'oeil artists who preceded him. Kaye was born in Neemah, Michigan, and moved to New York in 1904. There he attended the New York School of Art and came into contact with Nicholas Alden Brooks (active 1888–1904), a noted still-life painter whose depictions of money, playbills, and posters would influence Kaye's own thematic preferences. From 1905 until 1914, Kaye lived in Germany, where he studied engineering and created delicate drawings of figures, animals, and insects. After returning to the United States, he settled in Pittsburgh until the mid-1920s, during which time he familiarized himself with the still lifes of Harnett. So inspired, he began painting depictions of currency in his spare time, working in the precise, highly detailed manner associated with the trompe l'oeil tradition. After about 1930, Kaye expanded his thematic repertoire to include other trompe l'oeil motifs, such as firearms and musical instruments. He also began to paint the figure and taught himself etching techniques by copying prints by Rembrandt and Whistler, always signing them with his own name. Kaye continued to paint, draw, and etch throughout the 1950s and 1960s, depicting money, paper oddities, and monumental figure compositions and landscapes. Kaye's wife and daughter died in a tragic car accident in the 1950s; about the same time, his son moved to Europe, virtually disappearing from sight. After making a short trip to New York in the spring of 1969, Kaye went to Dresden, possibly in search of his son and remained there until his death in 1974.

Louis Aston Knight

(1873–1948)

Louis Aston Knight was an avid outdoor painter who took great delight in depicting the fast-flowing rivers and streams of Normandy. Inspired by the Impressionist and realist traditions, he created lyrical images replete with water effects and outdoor light that reflect his belief that "Nature is beautiful enough to inspire masterpieces to those who are willing to copy it and to give to others the poetical effect nature expresses." Born in Paris, Knight was the son of the American expatriate painter Daniel Ridgway Knight (1839–1924). In addition to studying under his father, he attended classes at the Académie Julian from 1891 to 1898. His earliest landscapes were created in Normandy and Brittany and along the Seine, near Paris. He later worked in and around his country home at Beaumont-le-Roger, which he purchased in 1920. Prior to moving permanently to New York in 1940, Knight made lengthy visits to America, exhibiting in New York and Philadelphia and painting landscapes in Maine, Connecticut, and elsewhere in the northeast. He won many awards and honors in France and the United States. His popularity in America was much enhanced in 1922, when President Warren G. Harding purchased one of his paintings for the White House. Knight was also active in Venice (1907–13), England (1911–13), California (1930), and Jamaica (1936).

Myron Lechay

(1898–1972)

Known for his delicate colorism and graceful abstract designs, Myron Lechay created land-scapes and city views that have been compared to Stuart Davis's work of the 1920s and to Milton Avery's art of the 1940s. Born in Kiev, Russia, Lechay immigrated to the United States in 1906 and studied at the National Academy of Design. By the 1920s, he was participating in the New York avant-garde art scene. He met leading American modernists such as Davis and became a member of the Société Anonyme, through which he became familiar with the work of the American modernists as well as progressive European artists, including the Dadaists, Marcel Duchamp, and Francis Picabia. In the 1920s, Lechay's work was shown by New York's Valentine Gallery, where he had four one-artist shows and two retrospectives in 1932 and 1947. Critics applauded Lechay's visual economy and compared him to the French painters Henri Matisse, Piet Mondrian, and Raoul Dufy. Lechay's summer sketching forays took him to Gloucester, where he painted with Davis, as well as to Marblehead and Nantucket, and to Kennebunkport, Maine. Between 1921 and 1929, he worked in New Orleans on paint-ings of the city's French Quarter that brought him critical acclaim. Lechay maintained a studio in New York from the 1930s until his death in 1972. In addition to the Valentine Gallery and the Whitney Studio Club in New York, Lechay exhibited at the Carnegie Institute, Pittsburgh, the Brooklyn Museum, the Newark Museum, and the Pennsylvania Academy of the Fine Arts.

Richard Hayley Lever

(1876–1958)

Richard Hayley Lever was born in Australia and traveled to London to study art about 1894. He spent several years there before settling in the artists' colony at St. Ives, on the Cornish coast, where he painted harbor and littoral scenes in a lively Impressionist manner. About 1908 he came into contact with the work of Vincent van Gogh, whose vibrant colors and bold compositions exerted a lasting impact on Lever's work. In 1911, on the suggestion of his friend and fellow painter Ernest Lawson, Lever immigrated to New York. There he depicted the streets and harbors of Manhattan and associated personally and professionally with the group of artists known as the Eight. After first visiting Cape Ann, Massachusetts, in 1915, Lever made regular summer visits to the port towns of Gloucester and Rockport. He also worked in Nantucket, the Canadian Maritimes, and in the countrysides of New Jersey and Vermont. While nautical themes remained his forte, he also painted landscapes and still lifes. Lever taught at the Art Students League and offered private instruction in New York City and in Caldwell, New Jersey. He spent his final years in Mount Vernon, New York, where he was director of the Studio Art Club.

Luigi Lucioni

(1900–1988)

Described as an "individual realist" who followed his own path, Luigi Lucioni was a still-life painter whose renditions of fruit, flowers, and everyday household objects were acclaimed for their innovative designs, purity of color, and high finish. Painted in a meticulous style,

his still lifes prompted comparisons with Old Masters such as Jan van Eyke and Hans Holbein. Born in Malnate, in the Italian Alps, Lucioni and his family immigrated to America in 1910, settling in North Bergen, New Jersey. From 1916 until 1920, he attended classes at the Cooper Union School of Art in New York, where he was taught by the painter William Starkweather. He went on to study etching techniques at the National Academy of Design (1920–25), after which time a Tiffany Foundation grant provided him with the opportunity to visit Italy, where he was inspired by the aesthetic approach of Piero della Francesca and the Italian Primitives. After making his professional debut at the Ferargil Gallery in New York in 1927, he emerged as a major force on the art scene. The critic Henry McBride deemed him in 1936 the "most popular painter this country has produced since Gilbert Stuart." In 1939, Lucioni bought a farmhouse in Manchester, Vermont, where he spent his summers painting rural landscapes and making etchings.

Fernand H. Lungren
(1855–1932)

An illustrator and painter, Fernand H. Lungren specialized in views of the landscape and native peoples of the American West. He was born in Hagerstown, Maryland, and was raised in Toledo, Ohio. After studying art at the Pennsylvania Academy of the Fine Arts under Thomas Eakins, he moved to New York, where he rented a studio with the prominent painter and pastellist Robert Blum and found work as a commercial illustrator for *Scribner's*, *Century*, *Harper's*, and *St. Nicholas*. By the mid-1870s, Lungren was one of the most popular illustrators of his time, known especially for his lively views of New York streets. In 1878 he helped found the Tile Club, an association of young artists who gathered for the purpose of painting on decorative tiles. Among the club members were William Merritt Chase, J. Carroll Beckwith, John Henry Twachtman, Winslow Homer, J. Alden Weir, and Robert Blum. In 1882, Lungren traveled with Blum to Paris. After studying briefly at the Académie Julian, he visited the towns of Grez-sur-Loing and Barbizon, where he became acquainted with an international coterie of artists who were exploring plein-air painting. He returned to the United States in 1883 and settled first in New York before moving to Cincinnati, where local artists Joseph Henry Sharp and Henry Farny encouraged him to explore the American West as subject matter. Lungren moved to Los Angeles in 1903; three years later, he established his home in Santa Barbara, where he became an important figure in the Southern California art scene and, in 1920, helped found the Santa Barbara School of Art. After Lungren's death, a collection of more than three hundred of his works were donated to Santa Barbara State College, now part of the University of California, Santa Barbara.

Dodge Macknight
(1860–1950)

The watercolorist Dodge Macknight established a notable reputation in Boston art circles at the turn of the last century. A native of Providence, Rhode Island, he served an apprenticeship with a theatrical scene and sign painter before joining the Taber Art Company in New Bedford, Massachusetts, in 1878. In 1883 he went to Paris, studying under Fernand

Cormon from 1884 to 1886 and exhibiting his work at the Salons. In 1886 he met the Post-Impressionist painter Vincent van Gogh, whom he later visited in Arles and who influenced his penchant for bold colors. Between 1886 and 1897 Macknight traveled and painted throughout Europe and the Mediterranean. Returning to the United States in 1897, he lived in Mystic, Connecticut, before settling in East Sandwich, on Cape Cod, in 1900. Thereafter he spent his summers in locales that provided him with interesting scenery and strong sunlight, such as the Grand Canyon, Spain, Jamaica, and Morocco. With their intense hues, his watercolors shocked many contemporary reviewers but were admired by such progressive-minded critics and artists as Philip Leslie Hale and Denman Ross. Macknight's patrons included the important Boston collector Isabella Stewart Gardner, who displayed his striking watercolors in a specially created Macknight Room in her mansion at Fenway Court.

Willard Leroy Metcalf

(1858–1925)

Willard Leroy Metcalf, a leading American Impressionist, was best known for scenes of the hills and rural countryside of New England. Born in Lowell, Massachusetts, Metcalf began his career as a wood engraver and figure painter in Boston. In 1883, after studying at the School of the Museum of Fine Arts, Metcalf used the income from illustrations published in *Century Magazine* to travel to Europe. In Paris, he continued his training at the Académie Julian under Gustave Boulanger and Jules-Joseph Lefebvre. He spent his summers abroad in artists' colonies in the French countryside, where he painted images of peasants and soft tonal landscapes that reflected the influence of the French pleinairist Jules Bastien-Lepage. Metcalf might have visited Giverny, the home of Claude Monet, as early as 1885, and he was part of the group of American artists that spent the summer there in 1887. He returned to the Boston area in 1888 and settled in New York in 1891. In 1897 he became a member of the Ten American Painters, the group of Impressionist artists from New York and Boston who exhibited together for twenty years. In the early twentieth century, Metcalf formed his mature style, merging a realism reminiscent of the art of the Hudson River School with French Impressionism. He worked frequently at popular artists' colonies in Old Lyme, Connecticut, and Cornish, New Hampshire, as well as more remote locales, such as Chester and Springfield, Vermont, and Casco Bay and the Damariscotta peninsula in Maine.

Richard Miller

(1875–1943)

One of the foremost members of the Anglo-American artists' colony in Giverny, France, Richard Miller achieved international renown for his sparkling portrayals of women in interiors and sun-dappled flower gardens. His emphasis on pattern, line, and lively color contrasts exemplifies the decorative direction of Impressionism during the early twentieth century. A native of St. Louis, Miller studied at the St. Louis School of Fine Arts (1893–97). In 1899 he went to Paris, continuing his training at the Académie Julian. During the early 1900s, he taught at the Académie Colarossi and painted portraits, Dutch peasant subjects, and depictions of attractive female models in interiors, favoring a muted palette and solid

brushwork. He began summering in Giverny about 1906, at which time he adopted the bright hues and fluid technique of Impressionism and formed part of a circle of American figure painters that included Frederick Frieseke. He also disseminated Impressionist precepts by teaching outdoor painting classes in Giverny. Miller returned to the United States in 1914, residing in New York and St. Louis before moving to Pasadena, California, in 1916 to teach at the Stickney Memorial School of Art. In 1918 he settled permanently in Provincetown, Massachusetts, where he became an important member of the local artists' colony and painted sun-dappled interiors, landscapes, and marine scenes. Miller died in Saint Augustine, Florida, in 1943.

Hermann Dudley Murphy
(1867–1945)

A painter of quiet, sunlit landscapes and refined still lifes, Hermann Dudley Murphy was a significant figure in the Boston School of painting in the early twentieth century. He was born in Marlboro, Massachusetts, and studied at the School of the Museum of Fine Arts, under the eminent painters Edmund Tarbell and Frank W. Benson. On a stay in Paris in 1891, Murphy continued his training at the Académie Julian and became enthralled by the work of James Abbott McNeill Whistler, who inspired his preference for gentle, refined palettes and simplified, tonally unified compositions. On the completion of his studies in Paris, Murphy returned to Boston, where he became active in a number of local artists' associations. In the spirit of Whistler, he created frames for his own works that harmonized with the images portrayed; when he moved to Winchester, Massachusetts, he was joined in a framing business by Charles Prendergast, who shared his aesthetic. Working from a shop in the basement of Murphy's home, the two artists produced frames inscribed "Carrig-Rohane" after the name Murphy had given his home and studio. Their hard-carved, gold-leaf frames suited the gentle images favored by the leading artists of the time. Murphy's art encompassed portraiture and figural studies, tonal landscapes in the manner of Whistler, vibrant scenes inspired by trips to the tropics, and richly colored Impressionist still lifes. Murphy received many honors in the course of his career. In 1911, the City Art Museum of St. Louis (now the St. Louis Art Museum) held a three-artist show featuring Murphy's work along with that of Augustus Vincent Tack and William Baxter Closson.

John Francis Murphy
(1853–1921)

Called "the American Corot," J. Francis Murphy was a painter of Tonalist landscapes who was renowned especially for his small, intimate views of nature. He was born in Oswego, New York, and moved at the age of fifteen with his family to Chicago. Largely self-taught, he began his career as a stage and scene painter. After settling in New York in 1875, he worked as an illustrator and made sketching forays to the Adirondacks and to the area around Orange, New Jersey. His first works—crisp, descriptive images in the style of the Hudson River School—were based on a direct observation of nature. Later his style became more poetic. Reflecting the influence of Alexander Wyant and George Inness, he recorded his own emotional responses to landscape through an expressive use of tone and surface texture.

Robert Nisbet

(1879–1961)

The leading painter in Kent, Connecticut, during the early twentieth century, Robert Nisbet was recognized for his "keen ... perception of elusive and intangible moods" and for his thorough command of technique. In addition to painting poetic landscapes and seascapes, he was a gifted etcher whose work was widely collected during his day. Nisbet studied at the Rhode Island School of Design in his native Providence and at the Art Students League in New York. After further study and travel in Europe, he moved to Manhattan in 1907, remaining there until 1911, when he settled in South Kent. He depicted the local countryside in all seasons, favoring compositions with distinctive groupings of trees. He also painted views of rivers, brooks, and the sea, working in a style that conjoined Impressionist strategies of light and color with the decorative concerns of Post-Impressionism. He exhibited regularly in New York, Philadelphia, Chicago, and elsewhere, winning many awards and honors. He was a member and one-time president of the Kent Art Association.

Robert Emmett Owen

(1878–1957)

The Impressionist Robert Emmett Owen captured the varied moods of rural New England with a vernacular truthfulness that has been likened to the poetry of Robert Frost. Painting old homes and churches, country roads curving through hills and farmland, covered bridges, peaceful waterways, and wooded glades, he created images that epitomized the widespread appreciation in early twentieth-century of New England as the wellspring of American culture and of the nation's identity. Owen was born in North Adams, Massachusetts. He studied there at the Drury Academy, in Boston at the Eric Pape School, and in New York at the Art Students League, the Chase School, and the National Academy of Design. Upon settling in New York in 1901, Owen became a leading illustrator for prominent magazines, including *Harper's New Monthly* and *Scribner's*. He began to create works that reflected the influence of the American Impressionists Willard Leroy Metcalf, J. Alden Weir, and Childe Hassam. From 1910 until 1920, he lived in Bangall, Connecticut, now part of Stamford, and painted in the open air. After moving back to New York in 1920, Owen opened a gallery on Madison Avenue where he exhibited and sold his own work exclusively. The gallery remained open until 1941, when Owen moved to New Rochelle, New York, and became the artist in residence at the Thomas Paine Memorial Museum. Until the end of his life he continued to paint and to sell his works directly to a large and devoted group of collectors.

Eric Pape

(1870–1938)

Called "the Master of the Pageant," Eric Pape was a painter of historical and archaeological subjects and landscapes, an art teacher, and an illustrator. He was born in San Francisco and studied at the San Francisco School of Design, under Emil Carlsen, and in Paris at the Ecole des Beaux Arts and the Académie Julian. After spending a year in northern Germany in 1890, Pape traveled to Egypt, where he remained for two years. He established a studio in Cairo and traveled along the Nile and through the Sahara Desert. In the mid-1890s, he

returned to New York City, where he became a prominent illustrator and painter. Pape later visited Mexico and other foreign sites, portraying subjects of ethnological and anthropological interest. In 1898 he founded the Eric Pape School of Art in Boston, which became one of the largest art schools in the country, providing instruction to many artists who would later achieve renown. The school remained in operation until 1913. Pape had a home on Cape Ann toward the end of his life, residing at Manchester-by-the-Sea.

Margaret Jordan Patterson

(1868/69–1950)

A painter, watercolorist, illustrator, and woodblock printer, Margaret Jordan Patterson was born in Soerabaja, Java, the daughter of a Maine sea captain who inspired in her a love of travel she retained for the rest of her life. She grew up in the Boston area and trained at the Pratt Institute, in Brooklyn, under Arthur Wesley Dow. She also studied with the Spanish painter Claudio Castellucho in Paris and with Charles Woodbury in Boston, where she was based throughout her mature career. Patterson taught and was an active member of the local art scene. She, nonetheless, found the time to travel abroad often, painting in Holland, Normandy, Spain, Italy, Belgium, and France. She also explored favorite haunts on Cape Cod, Massachusetts, and Monhegan Island, Maine. Her style consisted of a delicate and precise brush handling that she used to portray a range of landscape subjects, including coastal, harbor, and garden scenes. From 1929 until her death, she focused on the vibrant and coloristic properties of flowers in woodblock prints and watercolors. She was also acclaimed for her works in other graphic mediums.

Edward Potthast

(1857–1927)

One of a number of important American Impressionists to emerge from the burgeoning art milieu of Cincinnati at the turn of the last century, Edward Potthast began his career as a lithographer for the Strobridge Lithography Company while studying art at the McMicken School of Design. Beginning in 1881 he spent three years in Europe, continuing his training at Munich's Royal Academy and adopting the fluent handling and subdued hues associated with Munich realism. On a second trip abroad in 1887, he went to France, where he brightened his palette in response to Impressionism. He settled in New York in 1895, initially working as a freelance illustrator before pursuing painting full-time. About 1910, Potthast began creating sparkling oils and watercolors of children frolicking in the surf at Coney Island, Far Rockaway, Ogunquit, Maine, and other local beaches. His oeuvre also includes land- and seascapes painted during summer trips to New England, and views of Central Park.

Arthur Henry Prellwitz

(1865–1940)

Arthur Henry Prellwitz was a landscape and figure painter as well as a teacher and art administrator who spent much of his career in his native New York City. At various times he was affiliated with artists' colonies in Giverny, France, and Cornish, New Hampshire. After attending the City College of New York from 1879 until 1882, Prellwitz studied at the Art

Students League with Thomas W. Dewing until 1887. He lived in France until 1890, attending the Académie Julian and spending time in Giverny, and he visited Spain in the autumn of 1889, with the artists William Howard Hart and Philip Leslie Hale. Prellwitz returned to New York in 1890. In 1894, he married the painter Edith Mitchell (1865–1944) and was appointed director of the Art Students League, an important administrative position that he retained until 1898. From 1891 until 1898, Prellwitz summered in Cornish, fraternizing with Dewing, Hart, and many other artists. After his studio-cottage was destroyed by fire in 1898, he began to spend summers in Peconic, Long Island, where he and his wife were joined by many of their artist friends. The Prellwitz's soon moved permanently to Long Island, settling into an early nineteenth-century house that they had transported to a promontory in Peconic Bay. In 1928 the couple returned to New York City, where they remained active in many artists' organizations.

Edith Mitchill Prellwitz

(1864–1944)

Edith Mitchill Prellwitz was a painter of Tonalist figurative works, still lifes, and landscapes. She was born Edith Mitchill in South Orange, New Jersey. On a trip to Europe from 1882 to 1883, she visited Germany, Italy, and Paris, studying the art that she viewed in museums. Her first formal art studies took place from 1883 through 1889, when she enrolled at the Art Students League in New York. There her teachers were George de Forest Brush and Kenyon Cox. In 1889, after completing an apprenticeship with the Tiffany Glass Company in New York, she traveled to Paris, continuing her training at the Académie Julian. She returned to New York in 1891, and in 1894 married the painter Arthur Henry Prellwitz, who had studied with Thomas Dewing. The artists spent summers in the artists' colony of Cornish, New Hampshire, where they lived near Dewing and the sculptor, Augustus Saint-Gaudens. After their Cornish home burned down in 1898, the Prellwitz's began spending summers in Peconic, Long Island. In 1913–14 they became full-time residents of Peconic, living in the home they had purchased on Indian Neck, a promontory that jutted into Peconic Bay. The artists lived in New York from 1914 until 1938, when they moved back to Peconic. Edith Prellwitz played an active role in New York art life at the turn of the last century, exhibiting her paintings at many venues including the annual shows of the Society of American Artists and the National Academy of Design, of which she became an associate in 1906.

Hovsep Pushman

(1877–1966)

A notable figure in the American still-life tradition, Hovsep Pushman achieved critical and popular acclaim for his poetic still lifes featuring antique objects of Asian origin. He was born in Armenia and received his training at the Constantinople Academy of Art, the Art Institute of Chicago, and the Académie Julian in Paris. While living in Chicago and Paris in the early twentieth century, Pushman painted brilliantly colored portraits of romantic subjects such as Nubian princesses, Kurdistanian hillsmen, and Spanish gypsies. From 1917 to 1919 he lived in Riverside, California, but by the mid-1920s he had settled in New York. There he continued to create portraits and figural studies, but his interest gradually shifted to still lifes, particularly those of the antique objects from the Near and Far East that he had begun

to collect: rare old tapestries and textiles; Syrian glass bowls; lacquered chests; small medieval carved figures of saints; Chinese Tang and Ming figurines; statues of Buddha and Genghis Khan; Kano-style screens; and bronze statuettes. Pushman's impeccable technique captured the iridescent qualities of their glazes and well-worn surfaces. His ability to summon the mystery and spiritual force of the objects has led to comparisons of his work to that of the eighteenth-century French still-life painter Jean-Baptiste-Siméon Chardin.

Robert Reid

(1862–1929)

Despite his early, extensive, academic art training, Robert Reid became one of America's first important Impressionist painters. His work often combined landscape with the figure and is conspicuous for its decorative qualities and ideal, poetic themes. Reid initially trained with two European academic painters, Otto Grundmann and Frederic Crowninshield, at the School of the Museum of Fine Arts, Boston, in 1880. He continued his studies in Paris in 1885 as a student of Jules-Joseph Lefebvre and Gustave Boulanger at the Académie Julian. The works he exhibited at the National Academy of Design and at the Society of American Artists after his return to New York in 1889 displayed lively brushwork and high-keyed colors and were increasingly cited by critics for their Impressionist qualities. During the next decade Reid also completed a number of important mural commissions in Chicago, Washington, D.C., New York, and Paris. In 1898 he became a founding member of the Ten American Painters, a group associated with the advent of American Impressionist painting. About 1920 Reid settled in Colorado Springs, Colorado, and devoted most of his time to portraiture.

Frederic Remington

(1861–1909)

Frederic Remington is recognized today as the premier artist of the American West. His rich body of work—in painting, sculpture, and illustration—portrays colorful aspects of late-nineteenth-century frontier life, while his realistic depictions of cowboys, Native Americans, miners, immigrants, and cavalry, together with lively compositions and engaging narratives, proved immensely popular with contemporary audiences. Remington's artistic training was not extensive. He studied drawing with John Henry Niemeyer at Yale's School of Fine Arts from 1878 to 1879 and attended a single painting class in 1886 with J. Alden Weir at the Art Students League. His first trip to the West was a brief tour of the Montana Territory in 1881; he soon embarked on a series of longer expeditions from Mexico to western Canada. Critical attention quickly followed when he exhibited paintings developed from the sketches he made during these travels. To help support his painting Remington sold many of his drawings to popular magazines and wrote and illustrated his own books and articles. In 1895 he began a series of sculptures with Western themes that demonstrated his extraordinary skill at suggesting action and movement. He largely turned away from illustration work after 1900 to focus more on painting, and his canvases were increasingly marked by looser brushwork, high-keyed colors, brilliant lighting, and atmospheric effects. In 1909, at the height of his popularity, Remington died of complications from acute appendicitis.

Louis Ritman

(1889–1963)

A talented figure and landscape painter, Louis Ritman was born in Kamenets-Podolski, Russia in 1859. He studied art in Chicago and Philadelphia before travelling to Paris in 1909, at which time he continued his training at the Ecole des Beaux-Arts and familiarized himself with contemporary French art, especially Impressionism and Post-Impressionism. In 1911 he made this first visit to the Anglo-American art colony in Giverny, where he fraternized with a group of American figure painters that included Frederick Frieseke and Richard Miller. Inspired by their example, he began painting attractive women in domestic interiors or sunlit flower gardens, working in a decorative Impressionist style characterized by lively patterning and highly structured compositions. Ritman spent thirteen summers in Giverny, producing monumental canvases of a highly intimate nature. His work was exhibited regularly in Paris and in the United States, attracting the attention of critics such as C. H. Waterman, who in 1919 lauded his "fine synthesis of colour, beautiful surface and rich composition," and described his canvases as "tender and charming in sentiment, well felt and sensitive in execution." Ritman remained in France until 1930, when he returned to Chicago and began teaching at the school of the Art Institute of Chicago. During the 1950s and up until his death in Winona, Minnesota in 1963, he painted landscapes in southeastern Michigan.

Theodore Robinson

(1852–1896)

A leading figure in the history of American Impressionism and an influential member of the Anglo-American art community in Giverny, France, Theodore Robinson evolved a highly lyrical style, successfully reconciling modern tenets of light and color with academic precepts of form and structure. Born in Irasburg, Vermont and raised in Wisconsin, Robinson studied at the Chicago School of Design (1869–70) before moving to New York in 1874, where he studied at the National Academy of Design and was among the artists who esablished the Art Students League. He went to Paris in 1876, working under Carolus-Duran and attending classes at the Ecole des Beaux-Arts. He returned to America in 1879, living in New York and Evansville before returning to France in 1884. He made painting trips to Barbizon, Grèz-sur-Loing and elsewhere, including Giverny, which he visited in 1885. Two years later he helped found the Giverny art colony, which remained his primary base until 1892. During these years, Robinson became friendly with Claude Monet and painted landscapes and figure subjects in a modified Impressionist style characterized by fluid brushwork and a delicate palette. He continued to make trips back to New York, where he served as a conduit for the dissemination of Impressionist precepts. He settled permanently in New York in December 1892 and thereafter painted in upstate New York, New Jersey, Connecticut and Vermont, applying Impressionist strategies to native scenery. He also taught outdoor painting classes in Princeton, New Jersey and Napanoch, New York. His influential career was cut short in April 1896 when he died in New York of an acute asthmatic attack. His diaries (1892–96; Frick Art Reference Library, New York) provide a valuable chronicle of the early history of American Impressionism.

Severin Roesen

(circa 1815 – circa 1872)

A major exponent of the bountiful tradition in American still life painting, Severin Roesen painted fruit and floral subjects in the meticulous realist style that prevailed in American art circles during the mid-nineteenth century. Thought to have been born in Cologne, Germany, Roesen began his career by painting flowers on decorative porcelains and enamelware. Around 1848, he emigrated to America and settled in New York, where he established himself as a painter of elaborate still lifes. His style—characterized by rich color, painstaking detail, high finish and an emphasis on botanical accuracy—was inspired by the seventeenth-century Dutch still life tradition and by his earlier work as a decorative artist. His arrangements were typically lavish and opulent, conveying the sense of abundance and optimism that prevailed in pre-Civil War America. In 1858, the artist moved to Pennsylvania, residing in Philadelphia, Harrisburg and Huntingdon before settling in Williamsport, a thriving lumber town, around 1860. There, he painted and taught still life painting to Henry W. Miller, Lyle Bartol and others. His lush and highly elegant compositions inspired the work of many of his contemporaries, among them John Francis. Roesen died around 1872, possibly while en route to New York City.

Chauncey F. Ryder

(1868–1949)

An important figure in the American Tonalist movement, Chauncey F. Ryder was acclaimed for poetic and lyrical images of the New England landscapes, painted in a style characterized by softly blended tones, layered pigments, and broad brushwork. He was born in Danbury, Connecticut, and studied in Chicago at the Art Institute and at Smith's Art Academy. In 1901 Ryder traveled to Paris, remaining there for six years while he studied at the Académie Julian and exhibited annually at the Salon. Although he maintained a studio in Paris until 1910, Ryder returned to the United States in 1907 and settled in New York. He made summer visits to the artists' colony of Old Lyme, Connecticut, until 1910, when he established a home and studio in Wilton, New Hampshire. Ryder spent summers in Wilton for the rest of his life, using the town as a base to travel to sites in Massachusetts, Maine, and elsewhere in New Hampshire in search of painting subjects. Although best known for his oils, Ryder was also a proficient draftsman, printmaker, and watercolorist. He received numerous awards and prizes and was named full academician of the National Academy of Design in 1920.

Joseph Henry Sharp

(1859–1953)

A gifted figure painter, Joseph Henry Sharp was recognized for his romantic portrayals of Native Americans, from the Indians of the Great Plains to the Pueblos of New Mexico. He was especially admired for his emphasis on realism and accuracy, distinguishing the members of one tribe from another by carefully noting differences in physiognomy, costume, and artifacts; as a result, his work was lauded by collectors and anthropologists alike. Born in Bridgeport, Ohio, Sharp became deaf as a child after a near-drowning incident. He initiated formal studies at the McMicken School of Design in Cincinnati in 1874 and spent several

years there before taking additional study in Antwerp (1881), Munich (1885), and Paris (1885). Inspired by the example of the Cincinnati-based Western painter Henry Farny, Sharp chose to specialize in Indian subjects, taking extended visits to reservations where he painted, sketched, and took photographs. Sharp taught at the Cincinnati Art Academy from 1892 until 1902. In 1913, he settled permanently in Taos, New Mexico, becoming a founder of the Taos Society of Artists and one of its most respected members. He also maintained homes in Hawaii and California, where he painted colorful landscapes, marines, and floral still lifes. After Sharp's death in Pasadena in 1953, the painter Ernest Blumenschein declared, "He will go down in history with Russell and Remington and the few early artists of Indian life."

William Starkweather

(1879–1969)

Born in Edinburgh, Scotland, William Starkweather and his family immigrated to the United States in 1883, settling in New Haven, Connecticut. He attended the Art Students League in New York and the Académie Colarossi in Paris before going to Seville in 1903, where he spent three years studying under the Spanish Impressionist Joaquín Sorolla y Bastida, whose work he deeply admired. He returned to New York about 1906, painting landscapes and urban scenes in which he conjoined Sorolla's bright colorism and fluid technique with his own powerful draftsmanship. An inveterate traveler, Starkweather painted in the northeast United States and eastern Canada—especially Eastport, Maine, and Grand Manan Island, New Brunswick—as well as in Europe and the Caribbean. He exhibited his oils and watercolors at the various national annuals with great success. He taught at several institutions, including the Cooper Union School, Pratt Institute, and the Traphagen School before joining the faculty at Hunter College as an instructor of water-color painting in 1936. Having served as an assistant curator at the Hispanic Society in New York from 1910 to 1916, Starkweather wrote frequently about Spanish art. He also authored essays and articles on painters including John Singer Sargent, Winslow Homer, and Anthony van Dyck.

Zulma Steele

(1881–1979)

Among the talented women associated with the artistic life of Woodstock, New York, Zulma Steele devoted her creative energies to painting and printmaking. A notable figure in the Arts and Crafts movement, she also made pottery and furniture and was closely involved with book arts. Born in Appleton, Wisconsin, Steele studied at the Art Institute of Chicago and the School of the Museum of Fine Arts in Boston before enrolling at Pratt Institute in Brooklyn, where she was influenced by the aesthetic philosophies of Arthur Wesley Dow. After graduating from Pratt in 1903, she joined Byrdcliffe, the utopian artists' colony in Woodstock, where she designed mission furniture along with a colleague, Edna Walker. She went on to make pottery called "Zedware" and designed many books. Having attended Birge Harrison's outdoor painting classes in Woodstock, she also painted rural landscapes and the occasional urban scene in an Impressionist-inspired manner. Steele married Neilson T. Parker, a farmer, in 1926. After his death two years later, she made a number of trips abroad, but she continued to reside in Woodstock until 1967.

Annie G. Sykes

(1855–1931)

Lauded for her colorful, Impressionist-inspired watercolors, Annie G. Sykes was one of several prominent women associated with the artistic milieu of Cincinnati at the turn of the last century. She was born Annie Sullings Gooding in Brookline, Massachusetts, and studied at the Lowell Institute in Boston and at the School of the Museum of Fine Arts during the late 1870s. After her marriage to Gerritt Sykes in 1882, she moved to Cincinnati, continuing her training at the Cincinnati Art Academy from 1884 to 1894. Despite the birth of two children, she continued to balance the demands of home life with her professional aspirations, exhibiting her watercolors locally and in Boston, Chicago, New York, and Philadelphia. On the occasion of her first one-artist show, held at the Traxel & Maas Gallery in Cincinnati in 1895, critics praised her fresh, vibrant colors and spontaneous technique: a reviewer for the *Cincinnati Enquirer* identified her as representing "the new school of impressionism." Sykes maintained a high standing among her peers and was often invited to serve on juries with such eminent painters as Frank Duveneck, Maurice Prendergast, and Edward Redfield. She painted in and around Cincinnati, Nonquitt, Massachusetts (where her family had a summer home), Bermuda, Quebec, Virginia, and Europe. Her oeuvre includes landscapes and street scenes, but she was most fond of depicting floral environments.

Edmund C. Tarbell

(1862–1938)

The leading member of the Boston Impressionists, Edmund C. Tarbell was born in West Groton, Massachusetts. In 1879, after studying under Frederic Crowninshield and Otto Grundmann at the School of the Museum of Fine Arts, Boston, he traveled to Paris, where he refined his drawing skills at the Académie Julian. Upon returning to Boston in 1886, he was active as a portraitist. During the early 1890s, Tarbell depicted genteel young women in sunlight, combining the bright hues and fluid handling of Impressionism with solid draftsmanship. By 1897, his influence in Boston art circles was such that the critic Sadakichi Hartmann coined the term "Tarbellite" to describe the work of Frank W. Benson, Joseph DeCamp, and other local artists working within a similar aesthetic framework. After the turn of the century, Tarbell adopted a more academic approach to Impressionism, focusing his attention on quiet interior genre scenes influenced by the seventeenth-century Dutch master Jan Vermeer. He continued to paint portraits as well as landscapes and the occasional still life. A member of the group known as the Ten American Painters, Tarbell regularly exhibited his work in Boston, New York, and elsewhere in the United States. He taught at the School of the Museum of Fine Arts, Boston, from 1889 to 1913. In 1918, he moved to Washington, D.C., where he assumed the directorship of the Corcoran School of Art and was in great demand as a portraitist. He retired to his summer home in New Castle, New Hampshire, in 1925, where he continued to paint until his death in 1938.

Allen Tucker

(1866–1939)

Often described as the "American van Gogh," Allen Tucker developed a distinctive modernist style that assimilated principles derived from Impressionism, Post-Impressionism, and Symbolism. He was acclaimed for his landscapes, which are notable for their light and atmospheric effects, but he also executed figurative compositions and allegories. Expressive brushwork and thickly applied pigment are defining traits of his technique. Tucker was born in Brooklyn and was trained as an architect, a profession he practiced until 1904, when he committed himself to painting. He was initially inspired by John Henry Twachtman, with whom he studied at the Art Students League and later by the work of Claude Monet and Vincent van Gogh. He worked primarily in New York, but traveled extensively in Europe, especially France. In 1911, Tucker became a charter member of the Association of American Painters and Sculptors, the organization responsible for presenting the influential 1913 Armory Show. He participated in that exhibition and headed the committee that produced the catalogue; he was also involved with the Society of Independent Artists, the Whitney Studio Club, and served as an advisor to Juliana Force, the first director of the Whitney Museum. An instructor at the Art Students League from 1921 to 1926, he also produced a significant body of critical writing including a book, *Design and The Idea* (1930). His first one-artist show was held in 1918 at the Whitney Studio Club, also the site of his memorial exhibition in 1939.

John Henry Twachtman

(1853–1902)

Revered as a "painter's painter," Cincinnati-born John Henry Twachtman was at the forefront of American avant-garde art movements of his time. Much of his early career was spent abroad. He studied in Munich from 1875 to 1878. In 1880, after a period of painting in New York, he went to Florence to teach at the school his friend Frank Duveneck had established there. He lived in France from 1883 through 1885, studying in Paris at the Académie Julian and painting in Normandy and Holland in the summers. After settling in Greenwich, Connecticut, in about 1889, he developed a distinctive Impressionist style, which was communicated to him in part by his friend Theodore Robinson, who had spent many summers close to Claude Monet, and in part by his exposure to French art in New York galleries. Yet Twachtman's Impressionist style may also be seen as evolving naturally from the artistic explorations of his earlier career, and his mature aesthetic was tempered by his personal response to nature and by his versatile and individual technique. In Greenwich, Twachtman focused on painting the familiar motifs found on his own property, modifying his handling to the particular qualities that a subject evoked. In 1897 he helped found the group of American Impressionists known as the Ten American Painters. From 1900 through his death in 1902 Twachtman spent summers in Gloucester, Massachusetts, where he worked *alla prima*, returning to the bold, painterly style of his Munich years but retaining the vivacity of his Greenwich art.

Elihu Vedder

(1836–1923)

An expatriate for most of his life, Elihu Vedder was one of America's most inventive and visionary artists. He is best remembered today for his superb illustrations of the *Rubáiyát of Omar Khayyám* and for his imaginative paintings with mystical or allegorical themes. He received his first art lessons from Tompkins Matteson, a genre and history painter from central New York. In 1856 he went to Paris and studied with François Picot, who taught him to work in a tight, linear, neoclassical manner. Vedder then traveled to Italy; in Tuscany he became friends with Giovanna Costa and other members of the Macchiaioli, who favored plein-air landscape painting with a strong romantic element. He also befriended the American theorist James Jackson Jarves, a collector of Italian primitive and Florentine Renaissance paintings. Although Vedder returned to New York in 1861 and supported himself with illustration work, he traveled back to Europe in 1866 and settled in Rome, where he lived the rest of his life. During later visits to England, Vedder became acquainted with the Pre-Raphaelite painters and the work of William Blake, sources that increasingly influenced his allegorical and proto-Symbolist imagery. A decorative quality also emerged in his work following his appreciation of English Aesthetic art. The fifty-five illustrations that he began in 1883 for an edition of the *Rubáiyát* proved enormously popular, firmly establishing his international reputation. Over the next four decades Vedder continued to expand his oeuvre, producing several important murals and a set of mosaics for the Library of Congress in Washington, D.C., in addition to an autobiography and two books of poetry.

Bessie Potter Vonnoh

(1872–1955)

Bessie Potter Vonnoh was a distinguished and highly dedicated sculptor. She was best known for small bronze statuettes of mothers and children that she imbued with intimacy and joy. She also depicted dancing girls, many of them conceived as garden sculptures and fountains, which she endowed with a sparkling animation through lively surface modeling. Born in St. Louis, Vonnoh studied under the sculptor Lorado Taft at the Art Institute of Chicago (1889–92). By 1894 she had established her own studio, where she made plaster statuettes of society women. On a trip to Paris in 1895, she met the sculptor Auguste Rodin and saw domestic figure paintings by Mary Cassatt and Pierre-Auguste Renoir, experiences that influenced both her style and subject matter. Following her marriage to the Impressionist painter Robert Vonnoh in 1899, she lived in New York and maintained a summer home in Old Lyme, Connecticut. She went on to achieve national acclaim, winning numerous awards and honors in major exhibitions. Vonnoh also produced portrait busts and life-size statues, mostly during the twenties and thirties.

Theodore Wendel

(1859–1932)

A pioneering figure in the history of Impressionism in the United States, Theodore Wendel was among the first generation of American painters to work in the Anglo-American artists' colony in Giverny, France. Born in Midway, Ohio, he studied at the University of Cincinnati's School of Design in 1876 and later after continued his training at the Royal Academy in

Munich. In the summer of 1879, he accompanied the painter Frank Duveneck and a group of his followers known as the "Duveneck Boys" to Italy, spending the next two years in Florence and Venice. He returned to America in 1881, residing in New York, Boston, and Newport, Rhode Island, before traveling to France in 1885 or early 1886; there he attended classes at the Académie Julian. Wendel spent the summers of 1886 and 1887 in Giverny, painting alongside Theodore Robinson, John Leslie Breck, and other young American painters who were drawn to the presence of Claude Monet, a resident of the village since 1883. Inspired by their example, he abandoned his academic style and turned to the bright palette and loose handling of Impressionism, producing lyrical views of the Normandy countryside. After returning to America in 1888, he settled eventually in Boston and applied Impressionist precepts to his oil and pastel renderings of the New England landscape. He later moved to his wife's family farm in Ipswich, Massachusetts, going on to portray the picturesque scenery in and around Ipswich and nearby Gloucester. His paintings were exhibited regularly in Boston, especially at the Copley Gallery, where he had several one-artist shows. An illness in 1917 cut short Wendel's painting activity; he died in Ipswich in 1932.

John Whorf
(1903–1959)

One of the most accomplished and esteemed watercolorists of the first half of the twentieth century, John Whorf created realist depictions of urban and rural imagery in a luminous, painterly style often compared with that of John Singer Sargent and Winslow Homer. He was born in Winthrop, Massachusetts, and received his initial exposure to art from his father, Harry C. Whorf, a commercial artist and graphic designer. He went on to study in Boston at the St. Botolph Studio and at the School of the Museum of Fine Arts, where his teachers were Philip Leslie Hale and William James. Whorf spent the summer of 1917 or 1918 in Provincetown, Massachusetts, attending classes with Charles W. Hawthorne and associating with such leading contemporary painters as Max Bohn and E. Ambrose Webster. About 1919 Whorf visited France, Spain, Portugal, and Morocco. In Paris he enrolled briefly at the Ecole des Beaux-Arts, the Grande Chaumière, and the Académie Colarossi. During his time abroad, Whorf increasingly turned away from oil painting to focus on watercolor, which suited his transient lifestyle and his expressive and aesthetic interests. After his return to Boston in the early 1920s, Whorf was commended in the press as Boston's leading watercolorist. He lived in Provincetown after 1937, although he continued to travel in the United States and abroad in search of painting subjects. Throughout the rest of his career, Whorf's realistic, fluidly painted works were highly popular and sought-after.

Guy Wiggins
(1883–1962)

One of the finest Impressionists of his generation, Guy Wiggins produced many views of New England, especially in the vicinity of Old Lyme, Connecticut, where he was a respected member of the local artists' colony. However, according to the artist, his favorite subject was "New York ... and New York when snow is falling." Indeed, Wiggins took great delight in exploring the pictorial possibilities of Manhattan, especially during winter, when falling snow envelops buildings and streets in a veil of soft atmosphere. His cityscapes—romantic and suggestive—were highly popular with collectors, who viewed them as pictorial

mementos of New York. Born in Brooklyn, Wiggins was the son of Carleton Wiggins, a prominent painter associated withas the American Barbizon tradition. He received his training at the National Academy of Design in New York, where his teachers included William Merritt Chase and Robert Henri. Wiggins divided his time between New York, where he could paint urban scenes from the windows of tall office buildings, and his farm in Hamburg Cove, Connecticut. In 1937 he moved to Essex, Connecticut, and founded the Guy Wiggins Art School and the Essex Painters Society. He also made painting trips throughout the United States, going as far west as Montana.

Irving R. Wiles
(1861–1948)

Working directly from his subjects and using bold, painterly brushwork, Irving Wiles produced hundreds of elegant, lively portraits and sunny landscape views. He painted in a modified Impressionist style close to that of his lifelong friend and mentor, William Merritt Chase. Wiles was born in Utica, New York, where his father, the landscape painter Lemuel Wiles, taught art in the public schools. About 1868, Lemuel Wiles moved his family to New York City in order to pursue his career as a painter. Irving began his art education in 1879, when he enrolled at the Art Students League. There he studied with Chase, who considered him one of his most talented students. Wiles subsequently attended the Académie Julian in Paris and later trained with Emile-Auguste Carolus-Duran, who affirmed Chase's own emphasis on individuality of brushwork and artistic self-expression. Returning to New York in 1884, Wiles focused on portraiture and figure painting while supplementing his income with illustration work. Over the next two decades he won a succession of important awards, but his portrait in 1902 of Julia Marlowe (National Gallery of Art, Washington, D.C.) earned him the accolades that facilitated later commissions from sitters such as Theodore Roosevelt and William Jennings Bryan. Wiles eventually built a house and studio in Peconic, Long Island, where he continued to paint and teach for the remainder of his life.

Theodore Wores
(1859–1939)

Renowned for his pictorial investigations into exotic and foreign cultures, Theodore Wores was the most important painter working in San Francisco at the turn of the last century. A native of that city, he attended the California School of Design before going to Munich in 1875, where he resumed his training at the Royal Academy and fraternized with artists such as Frank Duveneck and William Merritt Chase. In 1879, he became one of the "Duveneck Boys" who painted together in Florence and Venice and met the painter James Abbott McNeill Whistler, who introduced him to the art of Japan. Following his return to San Francisco in 1881, Wores depicted the Chinatown district and taught at the local Art Students League. He also traveled widely, including taking extended trips to Japan, where he painted portraits and landscapes in a style noted for its vivid chromaticism and impressionistic light effects. His articles on Japan were published in *Century* and *Scribner's*. Wores was also active in Hawaii and Samoa (1901), Spain (1903), the Canadian Rockies (1913), and the Southwest (1915). About 1918, he turned his attention to regional scenery, producing Impressionist-inspired landscapes and his so-called "Blossom Paintings."

Index to Illustrations

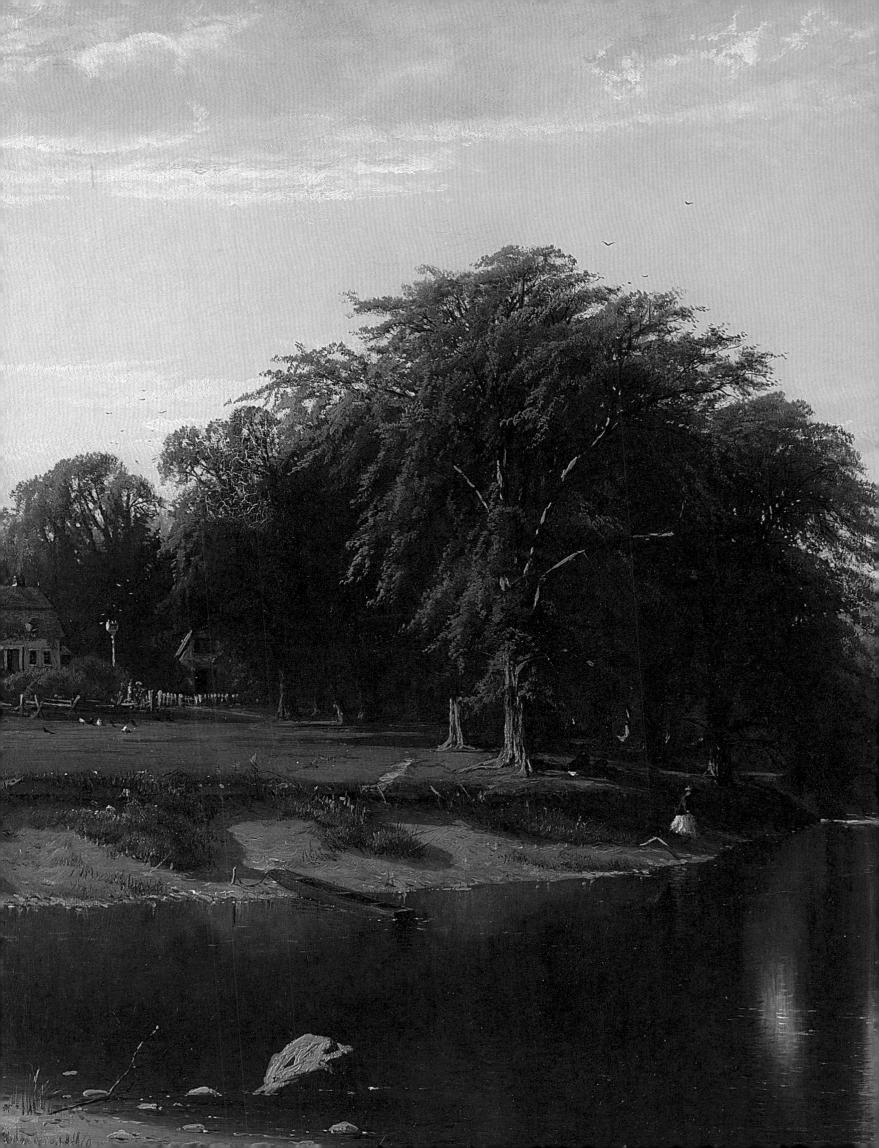